PAINTER'S QUICK REFERENCE

Landscapes

EDITORS OF NORTH LIGHT BOOKS

EX · LIBRIS

B. Robinson

NORTH LIGHT BOOKS
CINCINNATI, OHIO
www.artistsnetwork.com

Painter's Quick Reference: Landscapes. Copyright © 2006 by North Light Books. Manufactured in China. All rights reserved. It is permissible for the purchaser to paint the designs contained herein and sell them at fairs, bazaars and craft shows. No other part of this book may be reproduced in any form or by any electronic or mechanical means, including information storage and retrieval systems, without permission in writing from the publisher, except by a reviewer, who may quote brief passages in a review. The content of this book has been thoroughly reviewed for accuracy. However, the contributors and publisher disclaim any liability for any damages, losses or injuries that may result from the use or misuse of any product or information presented herein. It is the purchaser's responsibility to read and follow all instructions and warnings on all product labels. Published by North Light Books, an imprint of F+W Publications, Inc., 4700 East Galbraith Road, Cincinnati, Ohio 45236. (800) 289-0963. First edition.

Distributed in Canada by Fraser Direct
100 Armstrong Avenue
Georgetown, ON, Canada L7G5S4

Distributed in the U.K. and Europe by David & Charles
Brunel House, Newton Abbot, Devon TQ12 4PU, England
Tel: (+44) 1626 323200, Fax: (+44) 1626 323319
Email: mail@davidandcharles.co.uk

Distributed in Australia by Capricorn Link
P.O. Box 704, Windsor, NSW 2756 Australia

Other fine North Light Books are available from your local bookstore, art supply store or direct from the publisher.

10 09 08 07 06 5 4 3 2 1

Library of Congress Cataloging-in-Publication Data

Painter's quick reference : landscapes / editors of North Light Books.-- 1st ed.
 p. cm.
 Includes index.
 ISBN-13: 978-1-58180-815-5 (hardcover concealed wire-o : alk. paper)
 ISBN-10: 1-58180-815-1 (hardcover concealed wire-o : alk. paper)
 ISBN-13: 978-1-58180-814-8 (pbk. : alk. paper)
 ISBN-10: 1-58180-814-3 (pbk. : alk. paper)
 1. Landscape painting--Technique. I. North Light Books (Firm)
 ND1342.P255 2006
 751.45'436--dc22
 2005028862

Editors: Holly Davis and Stefanie Laufersweiler
Designer: Karla Baker and Kathy Bergstrom
Interior Layout Artist: Kathy Bergstrom
Production Coordinator: Greg Nock

F+W PUBLICATIONS, INC.

Metric Conversion Chart

to convert	to	multiply by
Inches	Centimeters	2.54
Centimeters	Inches	0.4
Feet	Centimeters	30.5
Centimeters	Feet	0.03
Yards	Meters	0.9
Meters	Yards	1.1
Sq. Inches	Sq. Centimeters	6.45
Sq. Centimeters	Sq. Inches	0.16
Sq. Feet	Sq. Meters	0.09
Sq. Meters	Sq. Feet	10.8
Sq. Yards	Sq. Meters	0.8
Sq. Meters	Sq. Yards	1.2
Pounds	Kilograms	0.45
Kilograms	Pounds	2.2
Ounces	Grams	28.3
Grams	Ounces	0.035

Introduction

WHEN YOU'RE IN A HURRY FOR PAINTING HELP, HERE'S THE BOOK TO COME TO FOR IDEAS, INSTRUCTIONS AND INSPIRATION.

Whether you wish to paint a grove of beautiful blossoming trees or a breathtaking sunset at sea, this easy-to-use reference will quickly show you how to do it. Each chapter focuses on a different major element of landscape painting, covering skies, terrain, foliage and water. You'll also find instruction pertaining to a variety of weather conditions and all four seasons.

Here twenty-one different artists share their painting secrets and expertise through clear step-by-step demonstrations and valuable "Artist's Comment" insights that are sure to give you exactly what you need. Refresh your skills by becoming reacquainted with fundamental painting techniques, or indulge in your adventurous side and explore new ones. And with painting instruction for three major mediums—acrylics, watercolor and oils— you not only gain advice and tips for your primary medium, but for other mediums you may want to try.

Are you seeking a new, fun way to paint trees? Do you want to portray a breaking wave, but have no idea where to begin? Do your storm clouds resemble gray cotton balls rather than threatening thunderheads? The solutions are easier than you think, and they are all within these pages. Simply turn the page, and start painting!

Table of Contents

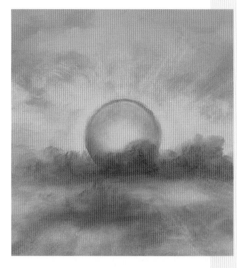

ROCKS & LAND

Skies & Clouds

The sky is either the starting point or the final task of a painting. You can build a picture around a dramatic sky, or a use a subdued sky to play a supporting role. In any case, know the purpose of your sky before you apply paint to paper. In this section you'll find many ways to paint the sky and its elements, including clouds, stars, rain, snow and the sun and moon.

Winter & Summer Skies

KERRY TROUT & JUDY KREBS

MEDIUM: *Acrylic*

COLORS: **DecoArt Americana:** *Baby Blue • Titanium White • Winter Blue*

BRUSHES: **Loew-Cornell:** *Series 7300 no. 14 flat shader • Item #91 speckling brush • Series 7500 nos. 8 & 10 filbert*

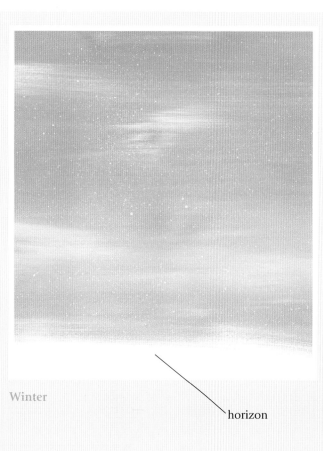

Winter

horizon

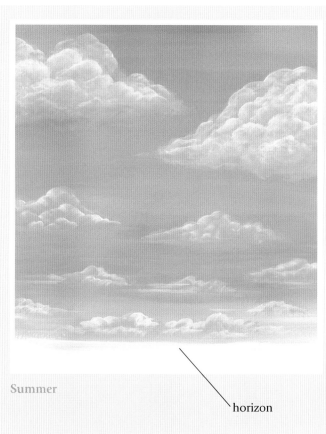

Summer

horizon

Winter

horizon

Summer

horizon

artist's comment

Remember that the sky always becomes lighter at the horizon. Also, clouds appear smaller as they recede toward the horizon.

1 Base In the Winter Sky
Base in the sky with Winter Blue, stroking horizontally with a flat shader. While this is wet, stroke in areas of Titanium White, using the same brush. Do not over blend. Let dry.

2 Spatter Snowflakes
(Refer to the painting on the opposite page, left.) Dip the speckling brush into thinned Titanium White and spatter lightly to make snowflakes.

1 Base In the Summer Sky and Clouds
Base in the sky with Baby Blue, stroking horizontally with a flat shader. While that is wet, start at the bottom (the horizon) and stroke in Titanium White with the flat shader, again using horizontal strokes. Blend this into the blue area.

Mix Baby Blue + Titanium White (2:1) with a bit of water and, starting at the top of the sky, apply clouds with a no. 10 filbert. Make the cloud tops rounded and puffy; let the bottoms appear more flat. Use a dabbing stroke to fill in the clouds for a mottled look. Keep the paint very thin and translucent.

2 Refine the Clouds
(Refer to the painting on the opposite page, right.) Use the edge of the no. 10 filbert to float Titanium White onto the largest clouds, following the contours of the mottled areas created in step 1. Switch to a no. 8 filbert to float Titanium White onto the smaller clouds. Use thinned white and the same brush to apply horizontal streaks around and through the clouds closest to the horizon.

Cloudy Daytime Sky

SHARON BUONONATO

MEDIUM: *Acrylic*

COLORS: **DecoArt Americana:** *Blue Mist • Buttermilk • Hi-Lite Flesh • Plum • Titanium White • Yellow Ochre •* **pale yellow mix:** *Buttermilk + Yellow Ochre (2:1) •* **gray lavender mix:** *Blue Mist + Plum (1:1)*

BRUSHES: **Sharon B's Originals:** *Crown •* **Generic:** *1-inch (25mm) flat*

OTHER SUPPLIES: *hair dryer (optional)*

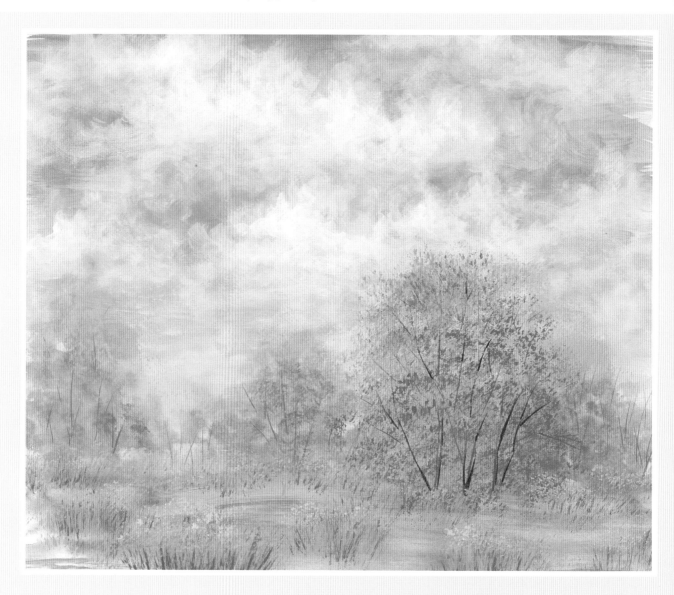

1 Base In the Sky

Apply thinned pale yellow mix to the lower half of the sky, stroking horizontally with a 1-inch (25mm) flat. Walk the brush from the bottom up to the center. Then rinse the brush and apply thin Blue Mist from the top of the sky downward in the same way. Wipe the brush on a paper towel and lightly drag across the center to blend where the two colors meet.

2 Add Clouds

While the colors are still wet, scumble on Hi-Lite Flesh cloud formations using a Crown brush. Fill in around the clouds with Blue Mist to separate. If the surface is not wet enough from the first application, dry it with a hair dryer set on low, re-dampen the surface with clean water and a flat, and then proceed. Note: Make sure the Crown brush is fully loaded to achieve a textural appearance on the surface.

3 Refine the Clouds and Add Shadows

Load the tip of the Crown brush with unthinned Hi-Lite Flesh and scumble over the previous dried application to form more distinct cloud formations. In the same manner, apply pale yellow mix on the tops of the clouds. Also apply gray lavender mix for shadows between the clouds in the previous Blue Mist areas.

4 Create Highlights

Load the tip of the Crown brush with Buttermilk and highlight the centers of the clouds, allowing the previous color application to show around the edges. Scumble horizontal wisps between the clouds with the remaining paint in the bristles. Using the tip of the Crown brush, add a final highlight of Titanium White to the cloud centers.

artist's comment

Do not paint all clouds the same. Vary their sizes and brightness for more depth.

9

Dramatic Cumulus Clouds

RICHARD SCHILLING

MEDIUM: *Watercolor*

COLORS: **Winsor & Newton:** *Burnt Umber • Cerulean Blue • Cobalt Blue • Davy's Gray • Payne's Gray • Permanent Sap Green • Raw Sienna*

BRUSHES: *1½-inch (38mm) flat*

OTHER SUPPLIES: *masking fluid • clean cloth • sketch paper • soft-lead pencil*

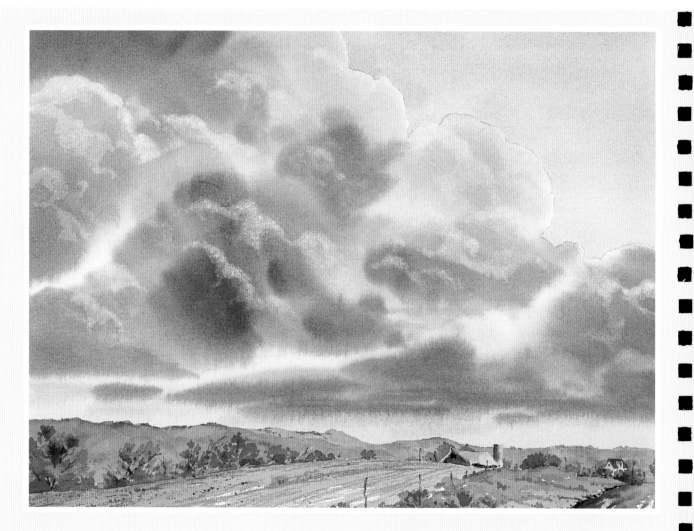

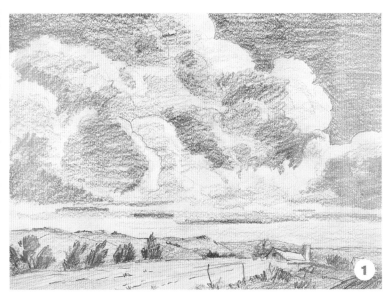

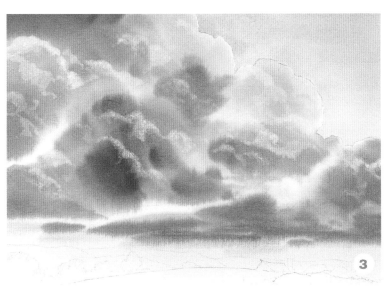

1 Plan Values

Before beginning the painting, make a simple value drawing with a soft-lead pencil to determine the placement of the lights and the areas to be painted later with masking fluid.

2 Work Wet in Wet

Prepare a wet-in-wet wash over the entire paper except in the area that will be blue sky. Try dropping in a number of different colors, using large brushes to lay in the pigments. They will fuse and create some interesting spontaneous effects.

3 Paint the Sky and Create Silver Linings

Paint the blue-sky areas with Cobalt Blue. You are now ready to make the "silver linings" of the clouds. With masking fluid, paint the areas that you wish to lighten. After it dries, remove the masking by rubbing it with a clean cloth, revealing lightened areas. Repeat the process if necessary to obtain the desired lightness. Note: This technique is most successful when the masking fluid is painted over darker passages.

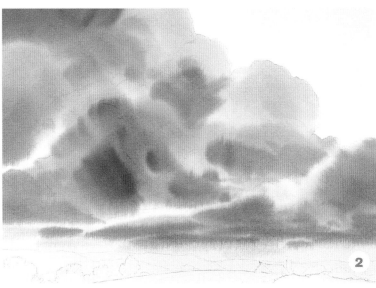

artist's comment

After painting cumulus clouds, I create their "silver linings" by applying and then removing masking fluid in certain areas. Picking up paint this way gives fluffy form to the clouds. Of course, one might lift color by applying water and blotting with tissue, but the results are often less realistic and not as dramatic.

Low Clouds

TOM JONES

MEDIUM: *Watercolor*

COLORS: **Rembrandt Water Colour:** *Hooker's Green Deep • Ultramarine Deep*

BRUSHES: **Silver Brush Ltd.:** *Black Velvet 1-inch (25mm) flat*

OTHER SUPPLIES: *300-lb. (640gsm) cold-press watercolor paper • facial tissue*

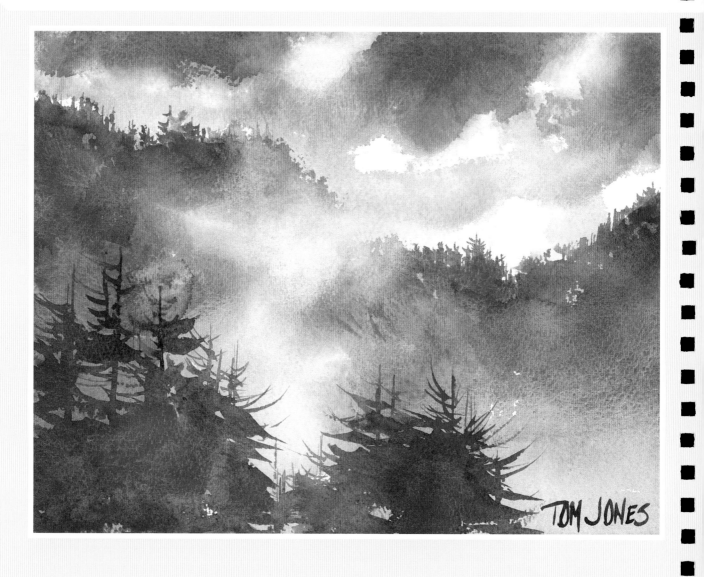

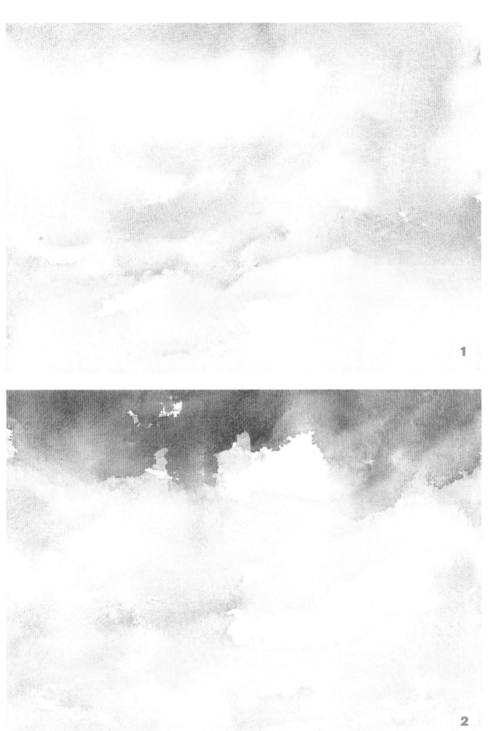

1 Apply Light Color

Mix a light value of Ultra-marine Deep + Hooker's Green Deep. Using a 1-inch (25mm) flat, apply a large amount of the light mixture where the sky will be. Leave the white of the paper showing in a few places.

2 Add Darker Color

Mix a darker value of Ultra-marine Deep and Hooker's Green Deep and darken the sky area at the top of the painting. This makes that part of the sky appear closer, creating depth. Soften some of the cloud edges in vari-ous areas by moistening them with a brush damp-ened with clean water and then blotting them with a tissue. Maintain a variety of soft and hard edges for a realistic look.

artist's comment

Many new painters tend to portray only white, puffy clouds or avoid clouds altogether and just paint the sky blue. For a change, try painting the morning clouds that hang low and come down into the mountain landscape. This is a scene you can see almost every morning in many mountain ranges.

Storm Clouds

Tom Jones

MEDIUM: *Watercolor*

COLORS: **Rembrandt Artist Brand Watercolors:** *Indigo • Ultramarine Deep*

BRUSHES: **Silver Brush Ltd.:** *Black Velvet 1-inch (25mm) & ¾-inch (19mm) flat*

OTHER SUPPLIES: *300-lb. (640gsm) cold-press watercolor paper • facial tissue • soft, flat-bristled, flat-handled toothbrush • hair dryer (optional)*

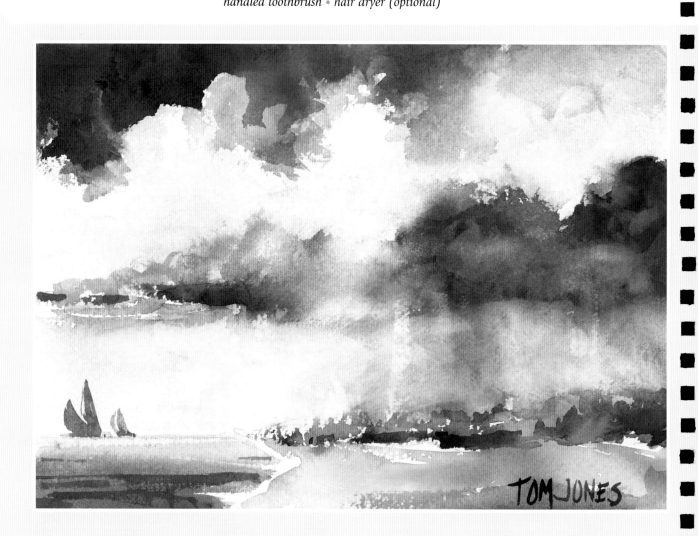

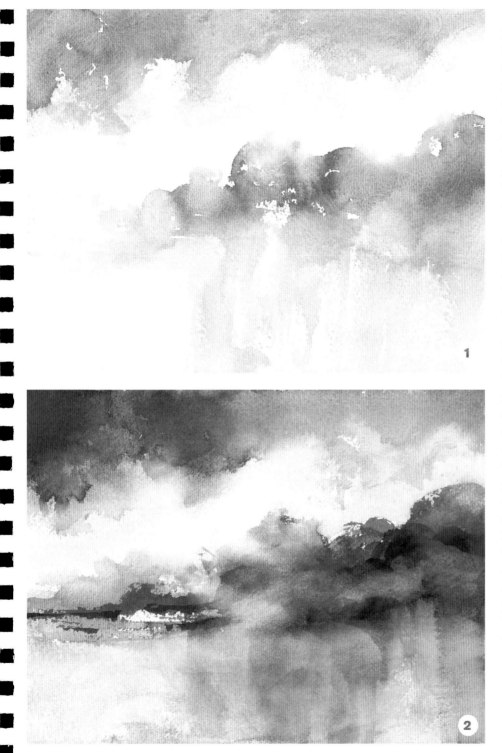

1 Form the Clouds While Painting the Sky

Start with a mixture of Indigo + some Ultramarine Deep and paint the sky at the top while simultaneously creating the edge of the white clouds. For variety, maintain some of the hard edges of the clouds while softening others with a damp brush and a tissue. This makes the clouds look more realistic.

Paint the darker cloud and suggest the look of falling rain by pulling down some of the color vertically with a flat brush. Let this stage dry before continuing with your painting.

2 Darken the Sky and Give the Clouds Depth

Use a darker value of the blue mixture to repaint the left side of the sky at the top and to add some darker color in the cloud on the bottom. Let this dry. Wet a toothbrush and then gently rub in a circular motion over the clouds to loosen some color. Pat this with tissues to lift a little color here and there. This gives the clouds some depth and keeps them from appearing flat. Continue pulling down color vertically below the clouds to reinforce the falling rain.

artist's comment

Dragging color in vertical brushstrokes is an easy yet convincing way to suggest falling rain, especially as viewed from a distance.

Thunderheads

TERRENCE L. TSEH

MEDIUM: *Acrylic*

COLORS: *Brown • Cerulean Blue • Payne's Gray • Raw Sienna • Titanium White (Note: Color names may vary according to paint brands.)*

OTHER SUPPLIES: *cellular (kitchen) sponge*

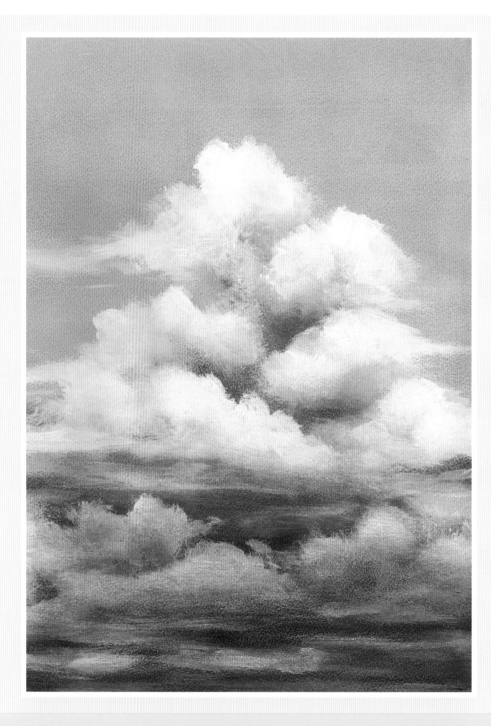

1 **Paint the Sky and Block In the Thunderhead**
Apply a wash of Cerulean Blue for the sky. Block in the thunderhead with Payne's Gray.

2 **Develop the Cloud Mass**
Use Titanium White to build the roiling cloud mass. Vary the shapes and the density of the paint.

3 **Darken the Thunderhead**
(Refer to the painting on the opposite page.) Darken the underside of the thunderhead by glazing Brown, Raw Sienna and Payne's Gray.

artist's comment

You can paint this sky and thunderhead with nothing more than a household sponge. The technique is fast and easy, which makes it especially helpful when painting murals.

Varying the thickness of the paint is crucial to portraying realistic clouds. Allow for thinner areas and let the sky show through in some spots.

Moons & Suns

Tom Jones

MEDIUM: *Watercolor*

SUPPLIES: *colors and brushes of choice • 140-lb. (300gsm) cold-press watercolor paper • pencil • spray bottle (1¼" [3.2cm] diameter) • box cutter • toothbrush (no specialized cuts or bristles) • facial tissues*

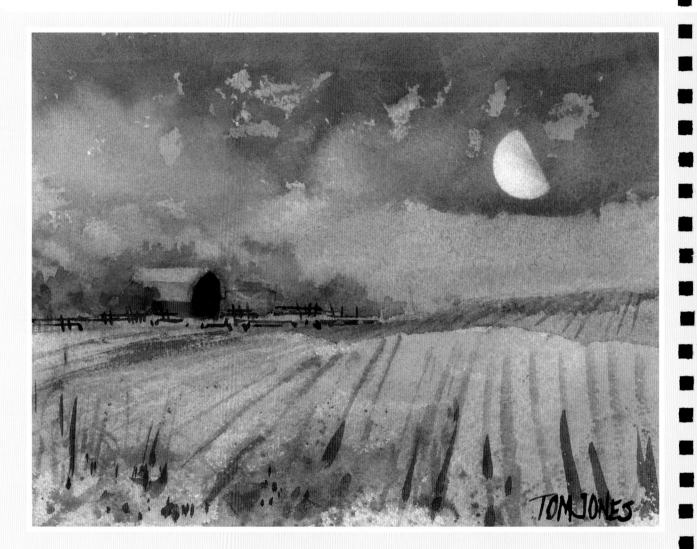

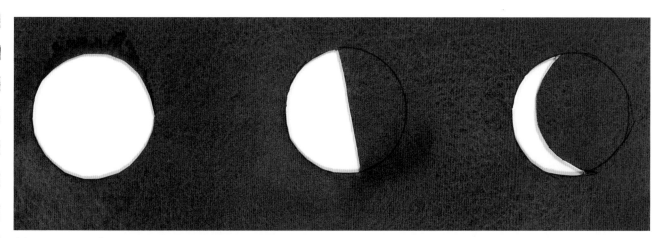

MAKING A STENCIL

On a scrap piece of 140-lb. (300gsm) cold-press watercolor paper, trace the bottom of a small spray bottle (about 11/4 inches [3.2cm] in diameter; no smaller), creating a sun or full moon shape. Then carefully cut the stencil with a box cutter. Cut a half-moon shape by cutting halfway around the circle and then across the center. For a quarter-moon shape, trace the full circle, slide the bottle sideways until you see the shape of the quarter moon, and then trace and cut the stencil.

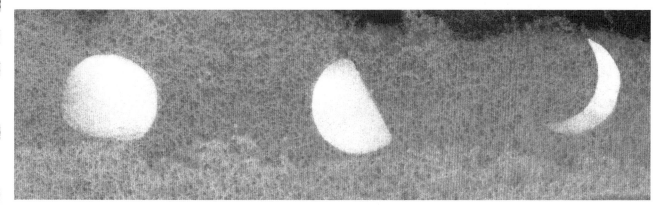

USING A STENCIL

Paint your sky as you wish. For this demonstration, I created a dark night sky. Make sure the painting is dry. Then hold your stencil firmly on the painting. Dip a toothbrush in clean water and, in a circular motion, gently rub out the color repeatedly. Use a tissue to lift the excess water and color. Change your tissue often to keep the stenciled moon or sun area clean. You can leave the stenciled sun or moon white or try one or more of the effects demonstrated on the next two pages.

artist's comment

When placing the sun or moon, think of your painting as a clock. Placing the sun at 10, 2, 4 or 8 o'clock is best. Do not put it directly in the middle of the painting, or on the center vertical line or center horizontal line. (Those are the lines you would see if you cut your paper into four equal smaller pieces.)

Moons & Suns

Leave part of the moon in shadow as you lift color. This creates a more natural look, with "lost and found" edges.

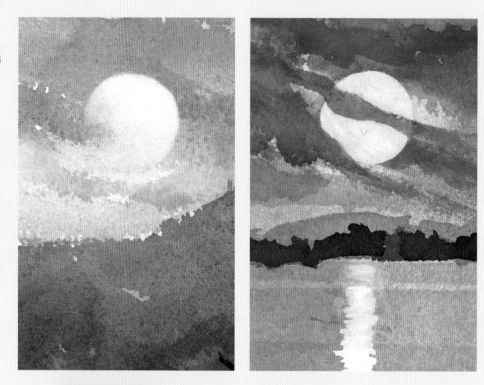

Try painting a few dark clouds in front of the moon for more drama.

MODELING THE SUN'S SHAPE

Here you can see how lifting color with a stencil while leaving color in other areas helps to create a convincing spherical shape.

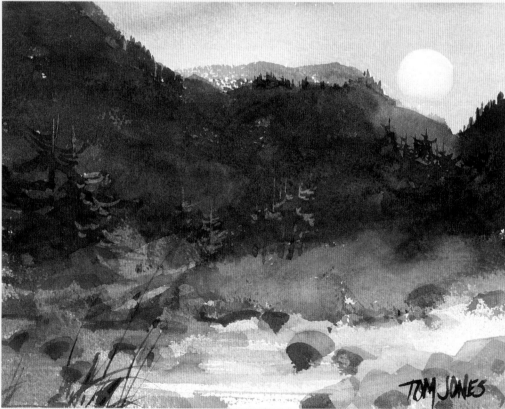

TOM JONES

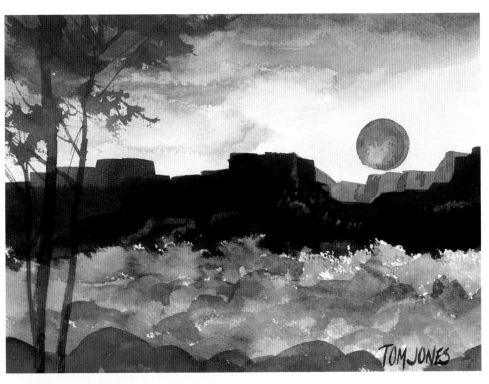

A COLORFUL SUN

Don't limit yourself to only yellow or white suns. This brilliant orange sun is a perfect fit for this desert scene, and it creates powerful impact through high contrast with the light sky surrounding it.

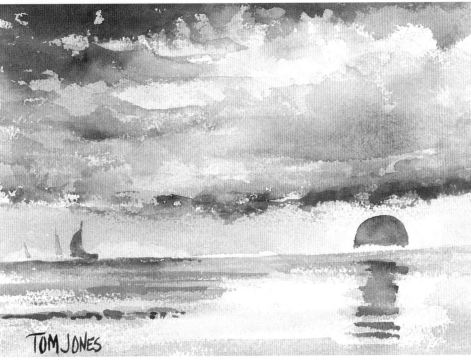

REFLECTING THE SUN'S COLORS

Be aware of how the color of the sun affects its surroundings. Here, the sun's mauve hue is reflected in the sky color and clouds as well as the water.

artist's comment

Don't be afraid to paint the moon or sun larger than you see it in nature. An enlarged moon or sun creates impact.

Sunset & Clouds

SHARON BUONONATO

MEDIUM: *Acrylic*

COLORS: **DecoArt Americana:** *Blue Mist • Buttermilk • Cadmium Orange • Cadmium Yellow • Plum • Pumpkin • Yellow Ochre* **pale yellow mix:** *Buttermilk + Yellow Ochre (2:1)*

BRUSHES: **Sharon B's Originals:** *Crown* **Generic:** *1-inch (25mm) flat • ¼-inch (6mm) angular • no. 3 round*

OTHER SUPPLIES: *hair dryer (optional)*

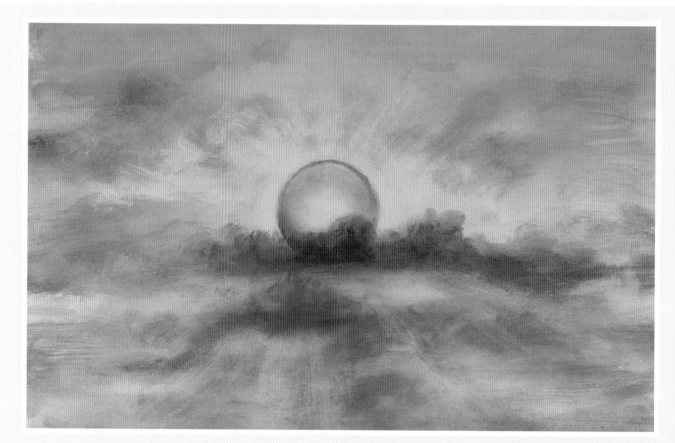

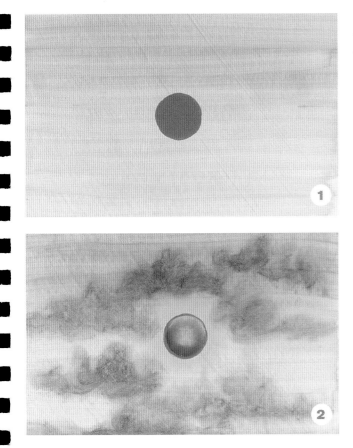

1 Paint the Sky and Sun

Use a flat to apply thinned pale yellow mix horizontally to the entire sky. While still wet, apply thin Blue Mist to the top of the sky and work down halfway. Wipe the brush and lightly blend where the two colors meet. Let this dry (or use a hair dryer). Lightly draw in the sun and then base in Pumpkin, using a round brush.

2 Add Form to the Sun and Paint the Darkest Clouds

Float pale yellow mix on the center of the sun by moving an angular brush in a tight circle. Float a highlight on the top of the sun. Shade the bottom of the sun with a float of Cadmium Orange. Create the glow around the sun with a float of pale yellow mix applied with an angular brush. Using a flat, dampen the surface with clean water. Then form soft Plum clouds with a Crown brush.

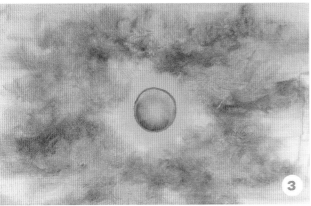

3 Develop the Sun and Add Clouds

Rehighlight the center of the sun, using pale yellow mix side-loaded on an angular brush. In the same way, repaint the glow around the sun with Cadmium Yellow. Let the surface dry and paint a thin coat of Cadmium Yellow over the entire sun, using a round brush. Using a flat, dampen the sky with clean water. Then use a Crown brush to add Cadmium Orange clouds. While wet, scumble in more clouds, using pale yellow mix.

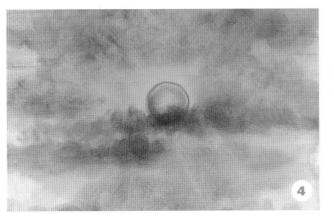

4 Add More Clouds and Sun Rays

Float more Cadmium Yellow to the sun's glow by walking the color out into the sky with an angular brush. Using a flat, dampen the sky with clean water. Then use a Crown brush to add Cadmium Yellow clouds in with the pale yellow clouds. While these are wet, scumble Plum clouds in the same manner over the base of the sun. Let the surface dry and pull sun rays out into the sky, using the tip of the Crown brush and Cadmium Yellow.

flip ahead ⇛

See pages 58-61 to discover how to paint a spectacular sunset light effect without painting the sun.

Sunrise/Sunset Sky

KERRY TROUT & JUDY KREBS

MEDIUM: *Acrylic*

COLORS: **DecoArt Americana:** *Baby Pink • Country Blue • Grey Sky • Taffy Cream • Titanium Snow White • Winter Blue*

BRUSHES: **Loew-Cornell:** *Series 7300 no. 14 flat shader • Series 7500 no. 6 filbert*

OTHER SUPPLIES: *facial tissue*

1 Basecoat the Sky

Use a flat shader to basecoat the sky with Winter Blue. Then pick up Titanium Snow White on the same brush—without cleaning it first—and stroke it into the blue. Paint wet-into-wet, and allow the sky to have subtle streaks of white in the blue.

Before the sky dries, stroke Baby Pink onto the horizon, blending it up into the blue and creating a light lavender.

2 Paint the Clouds

Brush a mixture of Taffy Cream + Baby Pink onto the pink horizon area. Let this dry. Mix Country Blue + Grey Sky (2:1) and use the filbert to paint skinny clouds near the now yellow-pink horizon area. Use a dabbing stroke, and give the clouds soft, irregular edges.

3 Add Reflected Light and Light Rays

(Refer to the painting on the opposite page.) Make the clouds smaller and lighter in color as they near the horizon. When the sky is dry, use a filbert to float reflected lights of Baby Pink and Taffy Cream onto the underside of the clouds.

Dilute Taffy Cream with water until it's very thin and runny. Then stroke rays of light from the horizon center into the sky, using a flat shader. Immediately soften these strokes with a tissue—the light rays should be almost invisible. Some rays should appear to be blocked by clouds. To accomplish this, apply cloud color to a few of the clouds so that they appear to be in front of the rays.

artist's comment

Clouds are never one solid color, so don't paint them that way. They reflect the colors present in the sky and in their surroundings.

Clouds at Sunset

KITTY GORRELL

MEDIUM: *Oil*

COLORS: *Cadmium Yellow Medium • Magenta • Naples Yellow • Perinone Orange • Phthalo Blue • Titanium White (Note: Color names may vary according to paint brands.)*

BRUSHES: *flat or wash for priming • ½-inch (13mm) bristle flat • no. 8 royal sable filbert*

OTHER SUPPLIES: *clear medium (optional—can be added to the oils help the paint move on your canvas) • orange acrylic paint*

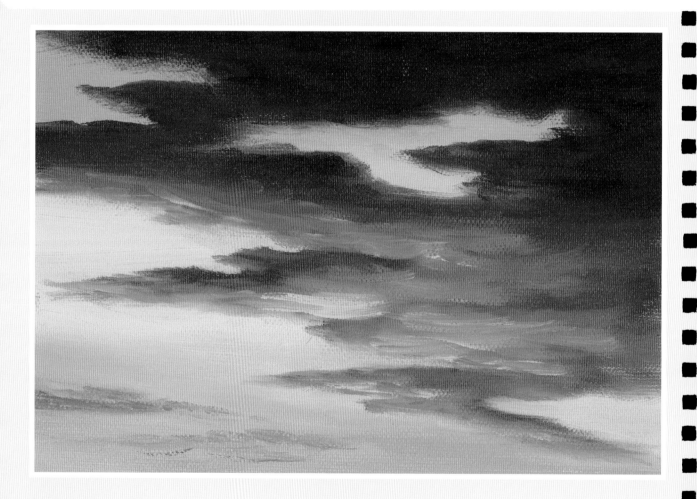

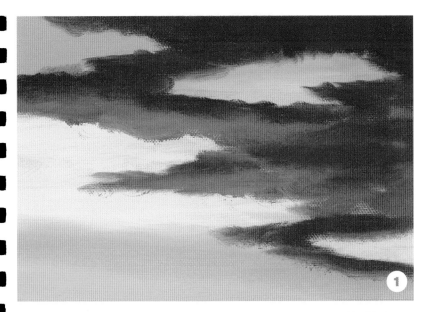

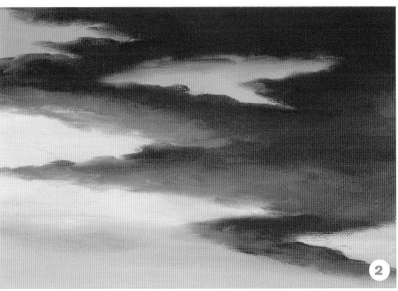

artist's comment

Here are a few tips for painting a vivid sunset in oils:
- Block in the strongest colors at the beginning to maintain their vibrancy.
- Lay the colors in with lean amounts of paint and very little blending.
- Often it's best to add the strongest glow of the sunset colors after the base painting has dried.

1 Start the Sky and Clouds

Prime your painting surface with a mid-value of acrylic orange paint. This base helps the similar strong colors that are to come to remain clean and vibrant. Use a bristle flat for the rest of this step. Brush mix Titanium White + a touch of Phthalo Blue for a light-value sky blue. With this color, base in the open sky areas in the middle. As you work toward the horizon, add more white to lighten the sky blue somewhat. As you work toward the upper sky, darken the mixture slightly by adding a bit more Phthalo Blue and a very small touch of Magenta to give it more of a shadow color. In the lowest sky area, touch in trace amounts of Naples Yellow.

With a brush mix of Perinone Orange + Magenta (4:1), add all the deep coral colors in the cloud formations. Add Titanium White to this mixture for the lighter areas.

2 Blend and Create the Glow

In this step, it's important to maintain color strength and not to overwork the paint. Using a filbert, blend the coral colors slightly where they meet. Clean up the edges of the cloud formations as needed. Begin adding the sunset glow to the downward regions of the clouds with Naples Yellow followed with a stronger glow of Cadmium Yellow Medium. Add slight pink tones with Titanium White + Magenta.

3 Add Shadows and More Glow

Refer to the painting on the opposite page. Lay in the deeper shadows of the clouds with a brush mix of Phthalo Blue + Magenta. Blend only slightly. Add more Cadmium Yellow Medium for the stronger sunset glow in the main cloud formation. Lay in these high-impact touches with the edge of a filbert, being careful not to over blend. Paint distant cloud touches with Perinone Orange and Cadmium Yellow Medium.

Evening Cloudscape

HUGH GREER

MEDIUM: *Acrylic*

COLORS: ***Golden Fluid Acrylics:*** *Anthraquinone Blue • Cerulean Blue Chromium • Diarylide Yellow • Quinacridone Magenta • Titanium White*

BRUSHES: ***Winsor & Newton:*** *Series 580 One-Stroke ⅛-inch (3mm), ¼-inch (6mm), ½-inch (13mm), ¾-inch (19mm) & 1-inch (25mm) • no. 0 script (Note: Unless otherwise specified, use large brushes to paint large areas and smaller ones for small areas.)*

OTHER SUPPLIES: *12" x 8" (31cm x 20cm) watercolor board or gessoed Masonite board, sanded smooth • paper towels • fine-mist spray bottle • pencil • cotton swabs • Golden Soft Gel Gloss (clear) • spray finisher for acrylics*

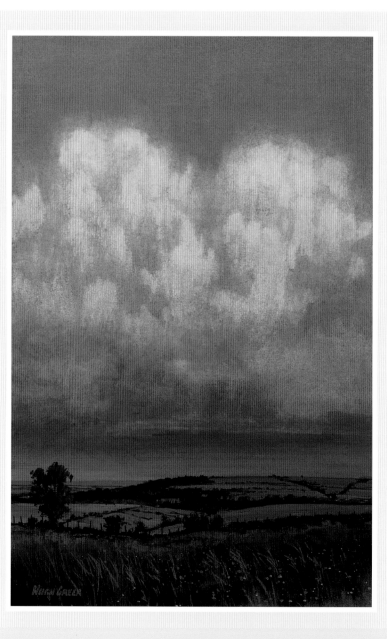

1 Prepare the Surface and Lift Cloud Shapes
Paint the support for your cloudscape with a mixture of
Quinacridone Magenta + Diarylide Yellow + Titanium White.
While wet, gently lift out some rough cloud shapes, using a
paper towel. Let this dry thoroughly.

2 Add Color and Lift More Clouds
Gently dampen the board with a fine mist of water and
paint a thin wash of Quinacridone Magenta + Diarylide Yel-
low at the bottom of the support and graduate about
halfway up the surface. While this is wet, use a wadded
paper towel to randomly lift out cloud shapes. Use the same
mixture in the sky above the clouds, using a paper towel to
lift out any excess color that might bleed into the clouds.
Keep the cloud tops bright and pure in color. Let dry.

artist's comment

A vivid underpainting immediately sets the stage for
clouds that glow.

Evening Cloudscape

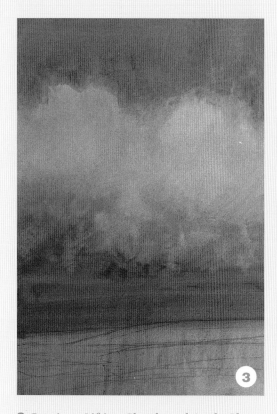

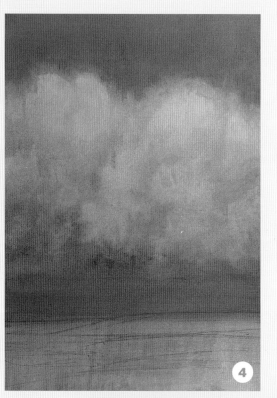

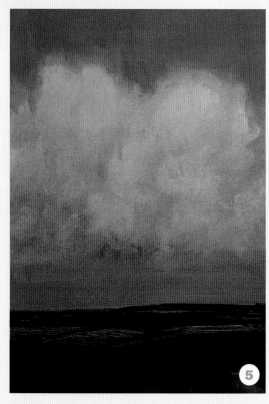

3 Continue Lifting Clouds and Apply Gloss
After lightly penciling in the foreground, mix a small amount of Cerulean Blue Chromium with the same Quinacridone Magenta + Diarylide Yellow mixture used in step 2, creating a warm purple. Paint this color onto the base of the clouds. While this is wet, use a paper towel to lift out some of the purple, giving the clouds a rounded shape and also exposing the color underneath. When thoroughly dry, apply three coats of Soft Gel, letting each coat dry before applying the next.

4 Develop the Surrounding Sky
Paint Cerulean Blue Chromium + Titanium White above the clouds. Wipe out color in unwanted places with a damp paper towel. Use this color within the clouds to define their shapes.

5 Paint the Foreground With the Sky in Mind
Rough in the foreground, giving the painting a base. Use mainly dark colors, because there's no sunlight on the ground; the sun hits only the clouds. You can make many greens and tans by adding Diarylide Yellow to Anthraquinone Blue and a small amount of Quinacridone Magenta. Add varying amounts of Titanium White to control values. Add detail to the foreground, using your script brush. Add some color to the sky with two or three thin layers of Cerulean Blue Chromium+ Titanium White.

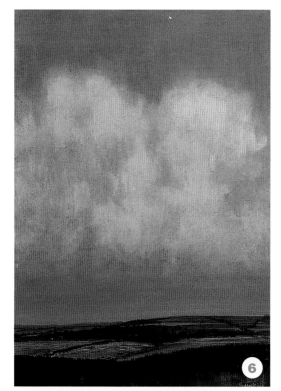

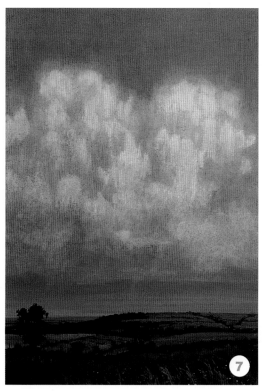

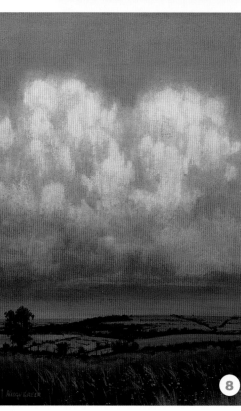

6 Go Over Entire Sky

If you like what you have so far, this step will be hard. Mix Cerulean Blue Chromium + Titanium White + a touch of Quinacridone Magenta. This new mixture should match the value of the sky above the clouds. Paint a very thin wash of this color (70 percent water to 30 percent paint) over the entire sky, including the cloud areas. You should still be able to see all of your painting underneath. This step will dull your painting, but don't panic; just work fast. While this mixture is wet, lift out highlights with a damp paper towel. Let this dry thoroughly.

7 Create Glow

Once more, wash the entire board with a very thin mixture of Quinacridone Magenta + Diarylide Yellow. After this has dried to the touch (but don't wait too long), use a cotton swab to lift out the highlights again. This is how you get that luminous, glowing color.

8 Finish the Sky Underneath the Clouds

Finish the foreground and then the sky. The color under the clouds is a warm, slightly darker purple made with Cerulean Blue Chromium+ Quinacridone Magenta + a small amount of Diarylide Yellow (the Diarylide Yellow helps tone down the purple).

 Note: This painting needs to be sprayed, rather than brushed, with a finish coat.

Starry Sky

TOM JONES

MEDIUM: *Watercolor*

COLORS: **Rembrandt Artist Brand Watercolors:** *Indanthrene Blue • Indigo • Ultramarine Deep*

BRUSHES: **Silver Brush Ltd.:** *Black Velvet 1½-inch (38mm) flat •* **Generic:** *old no. 6 or 8 round*

OTHER SUPPLIES: *300-lb. (640gsm) cold-press watercolor paper • Drawing Gum by Pebeo or other masking fluid • rubber cement pickup (optional) • small, fine-mist spray bottle • facial tissues*

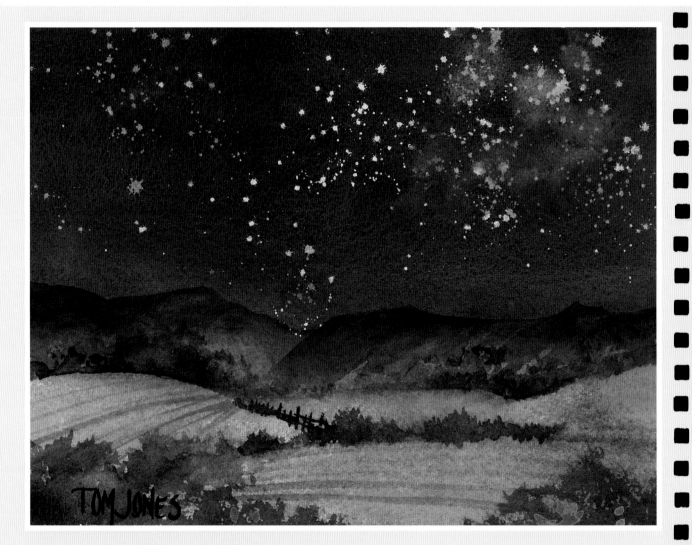

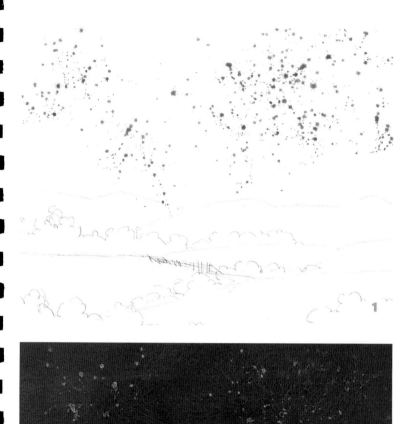

1 Save the Stars

After making a line drawing and delineating the area for the sky, use an old round to spatter masking fluid on the dry watercolor paper, protecting the white space that will become the stars. Make sure your spatters are irregular. Notice I have spattered a large cluster of spots on the right side and a smaller cluster on the left. This is the way stars appear in the sky. Let the masking dry completely.

2 Paint the Sky

Mix Indigo + Ultramarine Deep to get as dark a blue as possible. With the flat, paint the sky down past the top of the mountain. If your sky isn't dark enough, add Indanthrene Blue to the dark blue mix and repaint it. Let this dry. *Note:* It is best to let the sky area air dry. If you use a hair dryer you may inadvertently push the color around and wind up with a blotchy sky.

3 Soften the Stars

(Refer to the painting on the opposite page.) Remove the dried masking with a rubber cement pickup. As you will see, the contrast of the revealed white stars and the dark sky is a little overwhelming. Fill a small fine-mist spray bottle with some of the watered-down dark paint you used for the sky and carefully mist some of the areas away from the stars in the larger cluster to the right (leave those bright white). Let this dry. Then, using tissues dampened with clean water, very gently soften a small area of the stars in the larger area to the right for a Milky Way effect.

artist's comment

When saving the white of the paper for the stars, it is better to spatter more dots of masking fluid than fewer. After the masking dries and is removed, you can always tone down some of the star areas by adding color from a spray bottle.

Note that all resists are not the same. Some are too thick and some even stain the paper. I like Pebeo's Drawing Gum because it's fluid and lays flat as it dries. Whatever brand you use, try a few practice runs to see how it works.

flip ahead

See page 117 (step 4) to learn other ways of creating stars in a nighttime sky.

Night Sky With Moon Rays

Tom Jones

MEDIUM: *Watercolor*

COLORS: **Rembrandt Artist Brand Watercolors:** *Indigo • Ultramarine Deep*

BRUSHES: **Silver Brush Ltd.:** *Black Velvet 1-inch (25mm) flat*

OTHER SUPPLIES: *300-lb. (640gsm) cold-press watercolor paper • scrap piece of 140-lb. (300gsm) cold-press paper • facial tissues • box cutter • old toothbrush*

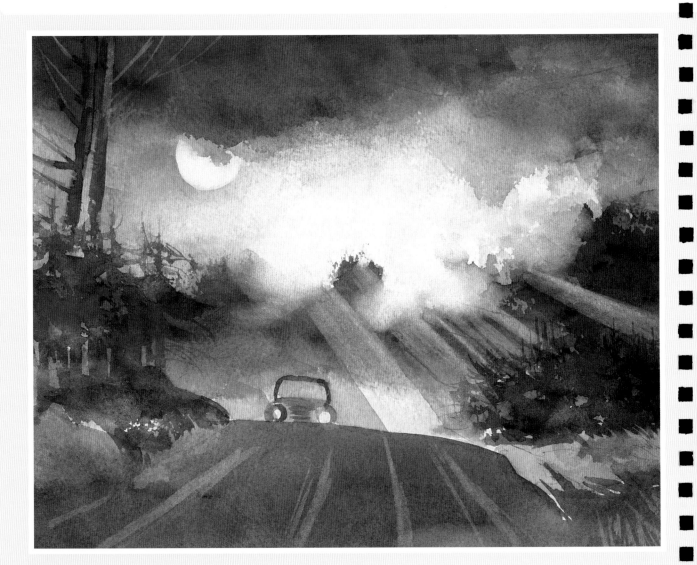

flip back

Turn to pages 19-21 to learn more about using stencils to paint the sun or the moon.

artist's comment

This technique of lifting off moon rays also works for creating sun rays.

1 Paint the Sky and Stencil the Moon

Mix a big pool of Indigo + a touch of Ultramarine Deep to make a dark blue. Paint the sky, at the same time creating the bottom of the cloud formation. With a damp flat, soften the edges of part of the cloud. Then pat with a tissue. This gives the cloud a more realistic look. Using the same dark blue, paint the dark area of sky at the top of the white cloud. Use the same flat with just water to pull down some of the color, creating some shadow in the cloud for a more look realistic look. Leave some areas of the cloud pure white. Let this dry completely.

Use a scrap piece of 140-lb. (300gsm) cold-press paper and a box cutter to make a stencil of a 1¼-inch (32mm) diameter circle. Place the stencil on the top edge of the cloud. With a old tooth-brush dipped in clean water, gently massage the area inside the stencil but leave some of the area dark to give the appearance of some dark cloud covering part of the moon. Lift the excess color and water with a clean tissue.

2 Create the Rays

Use a flat dipped in clean water to make marks in the shape of moon rays. With a tissue, quickly wipe in the direction of the rays, lifting color as you go. Make your rays different sizes with different-sized spaces in between to make them more realistic and interesting.

Trees & Foliage

There are as many types of trees and plants as there are ways to paint them; however, you don't need to be a gardening guru or an evergreen expert to convincingly depict these important landscape elements in art. As with most subjects in painting, success comes down to getting the basic shapes, colors and values right. With a little practice, you can liven up a landscape with any kind of foliage, near or distant.

Deciduous Foreground Tree & Bush

SHARON BUONONATO

MEDIUM: *Acrylic*

COLORS: **DecoArt Americana:** *Arbor Green • Asphaltum • Black Plum • Burnt Umber • Buttermilk • Olive Green • Plantation Pine • Pumpkin • Sable Brown • Soft Black • Yellow Ochre •* **pale yellow mix:** *Buttermilk + Yellow Ochre (2:1)*

BRUSHES: **Sharon B's Originals:** *Blade • Trident •* **Generic:** *1-inch (25mm) flat • no. 3 round • no. 1 liner • ½-inch (13mm) angular*

1 Lay In the Base Colors of the Bush

Unless otherwise indicated, all colors in this demonstration are applied with the chisel edge of a Blade brush. Start the bush by tapping Arbor Green on the surface to form a spider shape. Add Plantation Pine bush's center.

2 Add Dark Color

Darken the center of the bush by tapping on a scant amount of Black Plum.

3 Create Highlights

Tap Olive Green to highlight the light side of the bush.

4 Finish the Details

Tap pale yellow mix on the bush. Finish the bush by indicating broken-linework branches made with a liner and Plantation Pine.

artist's comment

Adding highlights and shading is key to bringing any subject to life. Without these details, a tree is just a shape without dimension.

Deciduous Foreground Tree & Bush

5 Start the Tree

Basecoat the tree with Sable Brown, using a round and a liner. Using a small puddle of Burnt Umber and one side of a Trident brush, pick up a tiny bit of paint and drybrush vertical lines to indicate bark. Start on the dark side of the tree and work your way across the trunk. Paint the branches the same way, following their direction from the trunk out. Drybrush highlighting on the bark the same way, using a small amount of Pumpkin on a clean side of the Trident brush. Wipe the brush and paint a Burnt Umber hole in the trunk with curving lines. Highlight the outside edges of the hole with Pumpkin in the same manner.

Paint the first application of leaves on a surface dampened with clean water and a flat. While wet, tap on somewhat triangular leaves using the chisel edge of a Trident brush and Plantation Pine.

6 Add Shading, Highlights and More Leaves

Add pale yellow mix to the Pumpkin areas of the bark, using one side of the Trident brush. Shade the dark side of the tree with a float of Black Plum, using the angular brush. In the same manner, darken the inside of the hole. Using Burnt Umber and the liner, detail the tree along the trunk and branches as well as the hole. Tap on more small individual leaves, using one corner of the Trident brush and Plantation Pine.

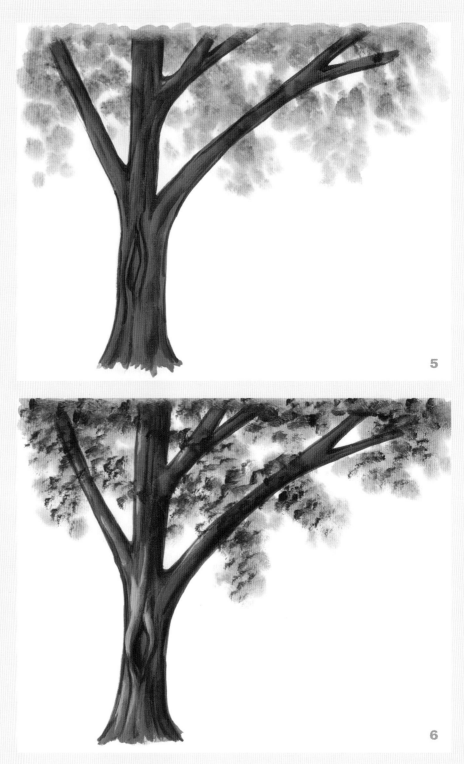

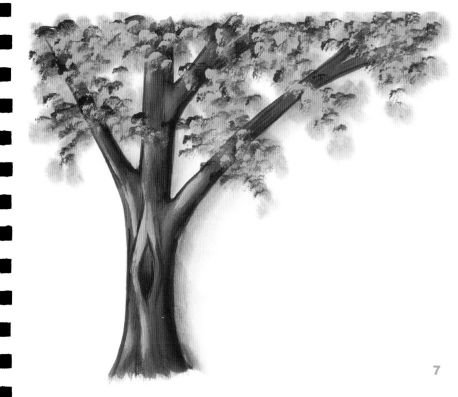

7 Develop the Tree and Add a Shadow

Re-highlight the trunk and hole with pale yellow mix, using one side of the Trident brush. Re-shade the dark side of the trunk, branches and hole using Soft Black side-loaded on the angular brush. Float a Plantation Pine shadow along the dark side of the tree trunk and branches (on the background) the same way. Tap on more small, individual leaves with one corner of the Trident brush and Olive Green mixed with the previous applications.

8 Soften and Finish

To soften the tree, wash over it with very thin Asphaltum using the round. Re-shade the tree's shadow as previously instructed. Finish the small individual leaves using pale yellow mix and one corner of the Trident brush.

7

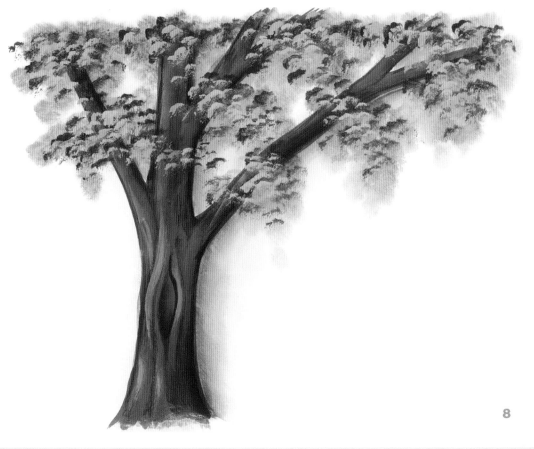

8

Tall Pines

MARGARET ROSEMAN

MEDIUM: *Watercolor*

COLORS: **Daler-Rowney:** *Quinacridone Magenta* • **Holbein:** *Indian Yellow* • *Permanent Rose* • **Winsor & Newton:** *Cerulean Blue* • *French Ultramarine* • *Winsor Yellow*

BRUSHES: *1-inch (25mm) flat gold sable* • *no. 5 round gold sable* • *no. 4 rigger*

OTHER SUPPLIES: *140-lb. (300gsm) cold-press watercolor paper*

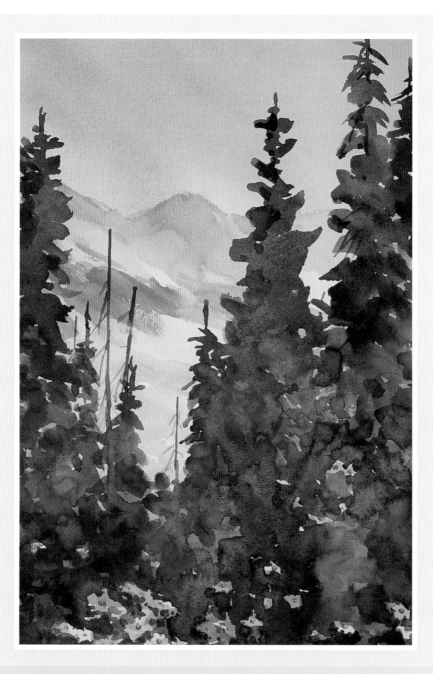

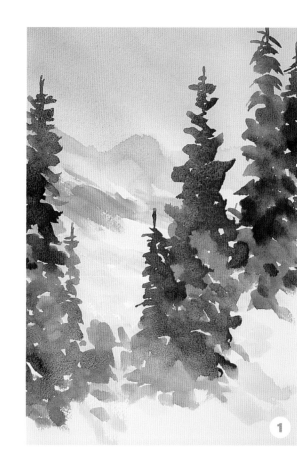

1 Paint Silhouette Shapes

Starting with the tops of the pines, place the trees so that each is at a different height. Essentially, you are painting the silhouette of each tree, making sure to create a unique shape for each. Use the flat and Winsor Yellow, Indian Yellow, Cerulean Blue, French Ultramarine, Quinacridone Magenta and Permanent Rose to form a variety of greenish combinations that range from warm to cool, light to dark. Let the colors mix on the paper as they are applied instead of pre-mixing them on your palette. Make some places a little more heavily pigmented than others, suggesting light variance.

2 Add Stick Trees to Balance the Large Pines

Continue the colors for the trees toward the bottom of the page, working around clusters of random white shapes that will become groupings of flowers. Splash in mixtures of Indian Yellow + Permanent Rose while the surface is still wet. Tilt the paper to encourage the colors to mingle and flow. With the rigger, paint a few graphic stick trees to break up the massive feel of the pines. Use shades of brown created from mixing Indian Yellow + Quinacridone Magenta + French Ultramarine. Remember to vary the height and spacing between trees.

3 Develop the Flowers at the Base of the Pines

Refer to the final step shown on the opposite page. When the paper has dried, use the round with Winsor Yellow and Indian Yellow to suggest the centers of the flowers in the foreground. Paint a thin line of Indian Yellow + Permanent Rose along the bottom half of some of the yellow centers. Once these areas have dried, use the flat to apply a light wash of French Ultramarine over some of the white flowers. This implies that these flowers are in the shadows created by the pines.

artist's comment

For spontaneous, surprisingly beautiful results, allow the tree colors to mix on your paper instead of pre-mixing them on your palette.

Foreground-to-Background Foliage

KITTY GORRELL

MEDIUM: *Oil*

COLORS: *Cadmium Yellow Light • Ivory Black • Phthalo Blue • Sap Green • Titanium White •* **sky blue mix:** *Titanium White + touch of Phthalo Blue •* **dark green mix:** *Sap Green + Ivory Black (3:1) •* **medium green mix:** *Titanium White + dark green mix (2:1) •* **light green mix:** *Titanium White + Sap Green (2:1)* (Note: Color names may vary according to paint brands.)

BRUSHES: *a firm filbert • no. 8 filbert • a stiff-bristled flat*

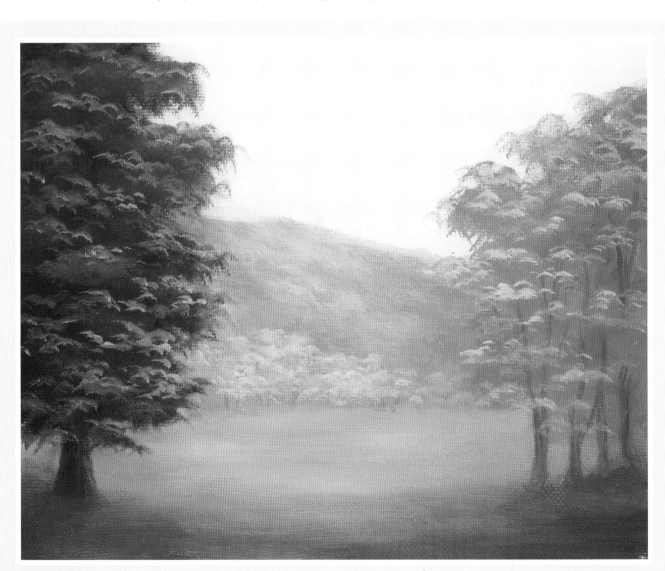

1 Paint the Distant Hills

Brush mix a touch of dark green mix into the sky blue mix for a pale, hazy gray-green. With this color on a firm filbert brush, create the distant hill formation. This is best done with a slight downward tapping stroke of the brush to form the shapes of the trees—but without too much paint or texture. The further away you want the hills to appear, the more subdued the color should appear.

2 Lay In the Ground

With medium green mix on a stiff-bristled flat, lay in the ground cover. Use minimal paint and smooth horizontal strokes. Work this color slightly upward into the base of the distant hills to lose any hard edges where the two elements meet. The greater the depth in the painting, the closer in value the land and foliage.

artist's comment

Many color combinations can be used when creating trees and foliage in a landscape painting, and a variety of combinations *should* be used to duplicate the wonders of nature. However, for this example I am using a very easy and limited palette to allow you to concentrate more on the values and textures than on the colors.

Foreground-to-Background Foliage

3 Establish Highlights and Depth

Brush mix the light green and sky blue mixtures plus a touch of Titanium White for a highlight on the tops of the very distant trees. As these trees come forward, make the color and value a little stronger to indicate closer detail. With a very pale brush mix of Titanium White + Cadmium Yellow Light, add the indication of sunlight on the distant and middle-ground land.

4 Begin the Grove of Trees

Using medium green mix on a no. 8 filbert, tap in the body of the middle-ground formation on the right that will become a grove of trees. Create the outer silhouette of the formation with a slight downward tapping stroke for soft edges and an irregular shape.

5 Paint the Foreground Tree and All Trunks

For a larger foreground tree, base in the tree shape using the dark green mixture. Using the same downward tapping stroke, create the outer silhouette of the formation. Brush mix a little extra Ivory Black into a touch of the medium green mix to make a darker value for the foreground tree trunk. Stroke in the trunks on the grove of trees on the right with a brush mix of the same color plus Titanium White.

6 Develop Form and Depth With Highlights

Add highlights to give form to all areas, from background to foreground. To help show that the distant hills and trees are far away, the highlights should be very minimal and close in value to the hill formation itself. Brush mix Titanium White + medium green mix and softly tap in the most distant highlights. Add more Titanium White and just a touch of Cadmium Yellow Light to the brush for the trees at the base of the hills in the background.

Brush mix the sky blue and light green mixtures (and more Titanium White if needed) for the highlights on the grove of trees. Try to maintain the openness of these trees, and allow their trunks to show through in several areas.

Because the large foreground tree is closest to the viewer, it has the strongest contrast between darkest shadows and brightest highlights. It also shows the most textures. Paint the highlights with light green mix first, then add the brightest highlights with touches of Titanium White + Cadmium Yellow Light.

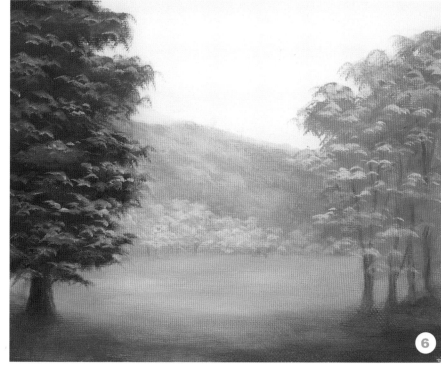

Negative-Painted Fruit Trees in Bloom

LINDA KEMP

MEDIUM: *Watercolor*

COLORS: *Aureolin Yellow • Cerulean Blue • Cobalt Blue • Rose Violet (Note: Color names may vary according to paint brands.)*

BRUSHES: *1-inch (25mm) flat wash • no. 10 or 12 round*

OTHER SUPPLIES: *5½" x 7½" (14cm x 19cm) good-quality watercolor paper • soft-lead pencil • hair dryer (optional)*

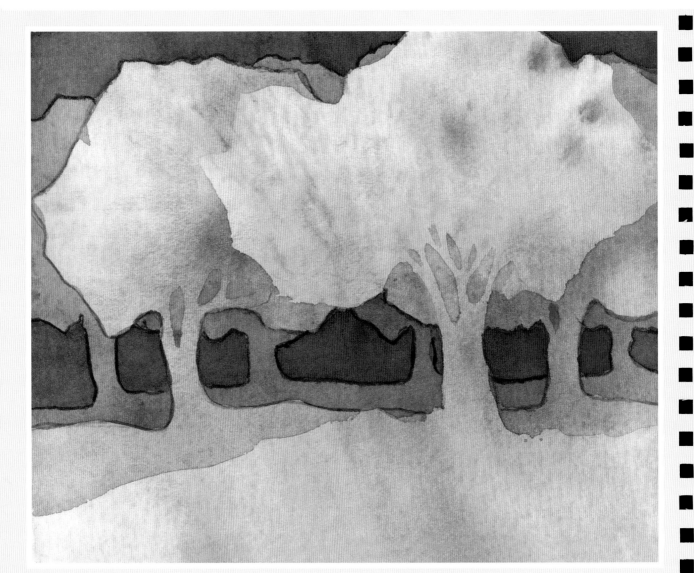

1 Establish a Colorful Wet-Into-Wet Underpainting
Saturate the paper with water, using a soft flat brush. Load a soft round with fresh Rose Violet, Cerulean Blue and Cobalt Blue by just folding the color together. Don't overmix. Press the tip of the brush to the paper and watch as the color spreads across the surface. Continue to fill the paper with random dollops of hues. Clean the brush well before applying Aureolin Yellow to the wet paper. Add a few spatters of color. Lift and tilt the paper to encourage the color to move. Let this step dry thoroughly before moving on.

2 Think Shape First
Begin by drawing a basic tree shape and small hill in pencil, or work directly as I have illustrated. The tree rises from the layer of land that it grows out of. Glaze around a basic tree shape with a watery mix of Cerulean Blue + Rose Violet. Work quickly to avoid backruns and hard edges within the wash as you pull the color away from the tree shape out to the edge of the paper. Allow the paper to dry, or use a hair dryer.

3 Position a Second Layer of Trees
Pencil in two new tree shapes. The key to working in the negative is that the layers are logically built from front to back or from foreground to middle ground to background. As the rows of trees move to the distance, they are tucked behind the previous tree.

artist's comment

Painting in the negative means that rather than filling in your subject with color, you paint around it to reveal its form. Here are a few hints for building layers of trees in the negative:

- To create a stand of trees that have been planted by nature, combine different sizes and shapes within the trees. Random spacing between the trees is another indication of natural growth.
- For fruit trees in an orchard, repeat similar shapes, sizes and spacings.
- Simply adjust the colors to suit autumn foliage, new spring growth or a particular species of trees.

Negative-Painted Fruit Trees in Bloom

4 Glaze Around the Tree Forms

Paint around and in the spaces between all of the trees with a combination of Cobalt Blue + Rose Violet. The value needs to appear darker than the previously painted color, but use enough water to allow the paint to spread and mingle. Again, wash the color out to the edges of the paper. Allow this to dry well.

5 Pencil a Third Layer

Sketch a new set of trunks and the rounded lower portion of their foliage in the spaces between the second layer of trees. The tops of these trees may extend above the treetops of the previous layers in a few places.

6 Fill In the Negative Spaces With Color

For the final glaze combine more Cobalt Blue + Rose Violet to make a darker value. Apply with a round in the negative spaces between and around the trees.

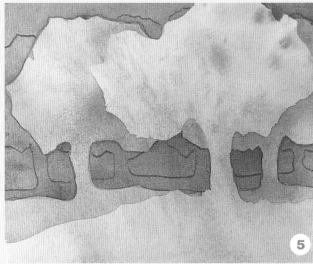

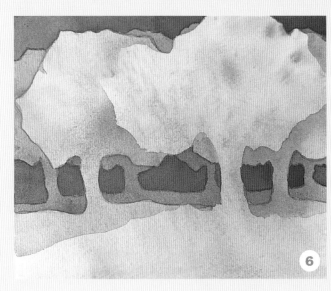

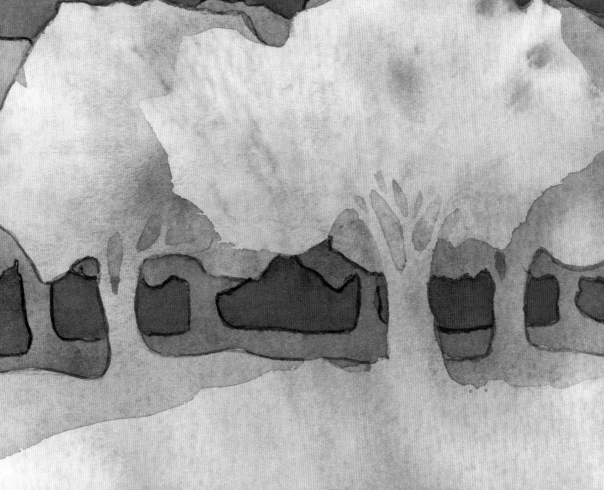

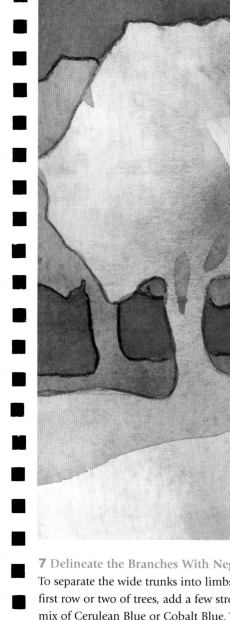

7 Delineate the Branches With Negative Painting
To separate the wide trunks into limbs and branches in the
first row or two of trees, add a few strokes of a light-value
mix of Cerulean Blue or Cobalt Blue. These strokes represent
the spaces between the branches. You may wish to lightly
pencil in the structures before adding the color.

flip ahead ⇨

*Turn to pages 81-82 to
learn another creative,
unconventional method
for painting trees.*

Near & Distant Greenery

HUGH GREER

MEDIUM: *Acrylic*

COLORS: **Golden Fluid Acrylics:** *Anthraquinone Blue • Cerulean Blue Chromium • Diarylide Yellow • Quinacridone Magenta • Titanium White*

BRUSHES: **Winsor & Newton 580 One-Stroke Series:** *⅛-inch (3mm), ¼-inch (6mm), ½-inch (13mm), ¾-inch (19mm) & 1-inch (25mm) • no. 0 script (Note: Unless otherwise specified, use larger brushes to paint large areas and smaller ones for small areas.)*

OTHER SUPPLIES: *8" x 14" (20cm x 36cm) multimedia board (or hot-press watercolor paper or board) • tracing paper • pencil • craft knife • paper towels • Golden Soft Gel Gloss (clear)*

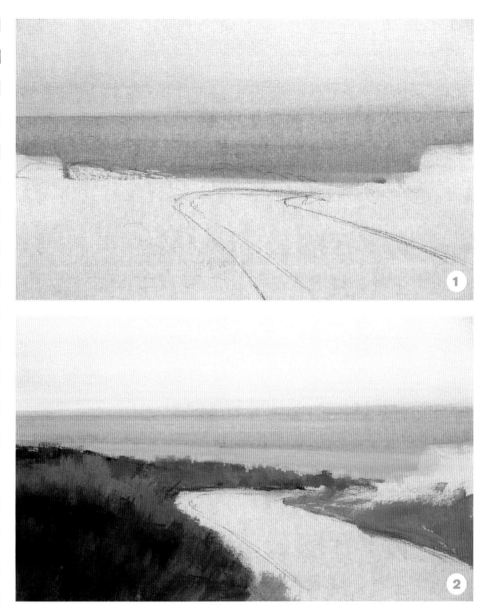

1 Paint an Overall Wash
and the Horizon
After penciling in the receding
road, apply a wash of warm
gray on the entire surface using
a mixture of Quinacridone
Magenta + Diarylide Yellow +
Cerulean Blue Chromium and
adding Titanium White to con-
trol the value. Apply a second,
darker layer of warm gray on
the sky and background area.
Once this is dry, establish the
horizon by painting a very thin
wash of pure Titanium White
on the sky area.

2 Scumble In the Grasses
To help define the road, scum-
ble in some dark foreground
grasses using Anthraquinone
Blue + Diarylide Yellow (1:1)
with a small amount of
Quinacridone Magenta, plus
Titanium White to vary the val-
ues. Add a wash of Titanium
White above the horizon.

artist's comment

Multimedia board is great for creating soft edges. If you want to give a feeling of
heavy atmosphere, this support makes it easy to accomplish. It reacts like good-
quality watercolor paper or watercolor board.

Near & Distant Greenery

3 Add Tree Mass on the Right and Distant Greens
Place a dark mass of trees on the right, using a mixture of Anthraquinone Blue + a small amount of Diarylide Yellow and a bit of Quinacridone Magenta. Do not render any definition in the mass at this point. Use a thin wash of grayed blue-green (Cerulean Blue + Diarylide Yellow) to define the foliage in the far back-ground. The farther away from the viewer, the lighter the color value should be.

4 Establish the Middle-Ground Foliage
Rough in some middle-ground foliage and trees, using a mixture of Anthraquinone Blue + a small amount of Diarylide Yellow and Titanium White. Dampen the foreground surface with a paper towel and scratch individual grass-blades with a craft knife.

5 Develop Roadside Foliage and Add Large Trees

Using the smallest one-stroke brush, rough in more foliage, including the large deciduous trees in the upper left and right, using a mix of Anthraquinone Blue + Diarylide Yellow + a small amount of Quinacridone Magenta and some Titanium White to vary the values. Notice how this heavy foliage on the right creates soft shadows on the foreground road. With the same brush, add individual leaves and limbs using Anthraquinone Blue + Quinacridone Magenta + a very small amount of Diarylide Yellow. With the same dark green mixture, define some of the bushes along the side of the road by painting the negative space behind them.

6 Define and Embellish the Foliage

On a piece of thin tracing paper, draw the outline of the two large deciduous trees in the upper right and left, and cut out the shapes with a craft knife. This creates a mask to protect the rest of the painting from unwanted spatters as you define these trees. Choose a brush to spatter color; I prefer the ⅛-inch (3mm) one-stroke brush. Spatter first with a lighter green (Anthraquinone Blue + Diarylide Yellow + Titanium White). While these droplets are wet, spatter a dark, almost-black, green (Anthraquinone Blue + Quinacridone Magenta + a small amount of Diarylide Yellow) onto the trees to establish pockets of dark that will define some leaf patterns.

Use the script brush to define a few individual leaves and to paint the tree branches with a mixture of Anthraquinone Blue + Quinacridone Magenta + a small amount of Diarylide Yellow. Use the same brush and colors of your choice to embellish along the road with a few of wildflowers. Use the Soft Gel gloss as a final protective varnish coat.

artist's comment

When spattering paint, realize that different brushes make different-sized droplets. The consistency of the paint will also make a difference, so experiment on a separate paper.

Stamped Forest

KATHI HANSON

MEDIUM: *Watercolor*

COLORS: ***Generic:*** *mop* • ***Winsor & Newton:*** *Antwerp Blue* • *Aureolin* • *Cobalt Blue* • *French Ultramarine* • *Payne's Gray* • *Winsor Yellow*

BRUSHES: ***Silver Brush Limited:*** *Series 3000S Black Velvet no. 8 round* • *Series 5300S Silver no. 12 round*

OTHER SUPPLIES: *300-lb. (640gsm) cold-press watercolor paper* • *paper towels* • *spray bottle* • *craft knife* • *museum board* • *masking tape*

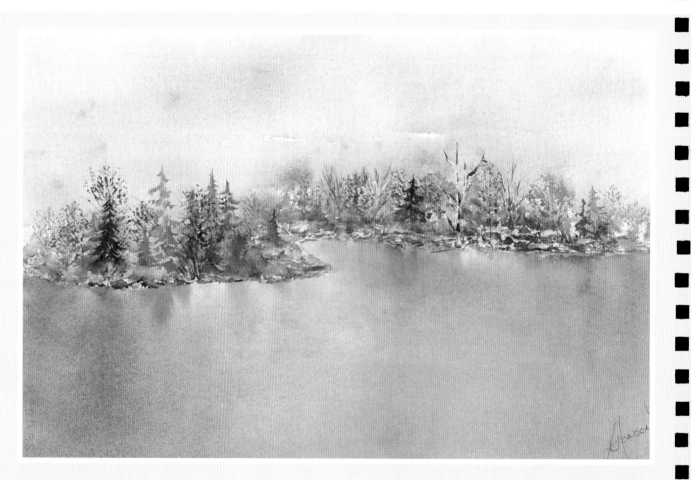

1

1 Paint the Ground and Sky

Spray water drops on the ground and sky area with a spray bottle. Leave small dry spots all over as you wet the majority of the area. Mix large puddles of the color mixtures listed below. Then load the mop brush heavily with paint and flick the paint off the brush and onto the paper into the wet areas. The paint will blend throughout the wet areas and stay out of the dry spots. Let the paper dry thoroughly after randomly placing these colors within the ground and sky area:

Mix 1 = Payne's Gray + Aureolin + Antwerp Blue

Mix 2 = Antwerp Blue + Aureolin

Mix 3 = French Ultramarine Blue + Winsor Yellow

Mix 4 = Cobalt Blue + Winsor Yellow

Mix 5 = French Ultramarine Blue + Cobalt Blue

Stamped Forest

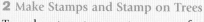

2 Make Stamps and Stamp on Trees

To make a tree stamp, cut a square of museum board and draw on it the trunk and branches of a tree. With a craft knife, cut fairly deep into each line you have drawn. Make a handle for the back side of the stamp by taking another piece of museum board, scoring it in four places equally distanced apart, then bending the scored areas up and connecting them. Tape the two open ends shut, then attach the handle to the back of the stamp with masking tape.

Load the round with a color of your choice and paint over each cut line. Stamp several practice trees on a scrap piece of paper before you stamp on your actual painting to make sure you have the stamp loaded properly. Evaluate your painting and then stamp the trees in. Make sure you have some on the distant horizon line as well as some in the foreground. Alter colors each time you stamp, and use a few different stamps if you're working on a large painting. Add partial foliage to some stamped trees, using any mixtures listed in step 1 and a round. You want the stamped branches and trunks to show in places, however, so don't overdo it.

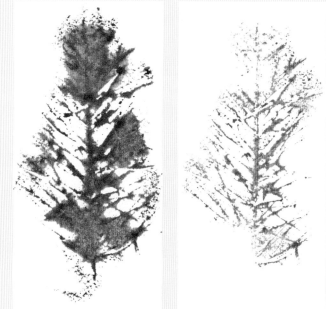

STAMPED DECIDUOUS TREES

artist's comment

If your aim is a realistic forest, the more irregular your stamping, the better. Don't fret over "imperfect" marks that show partial trees and bleeding color—these marks are perfect for a natural effect.

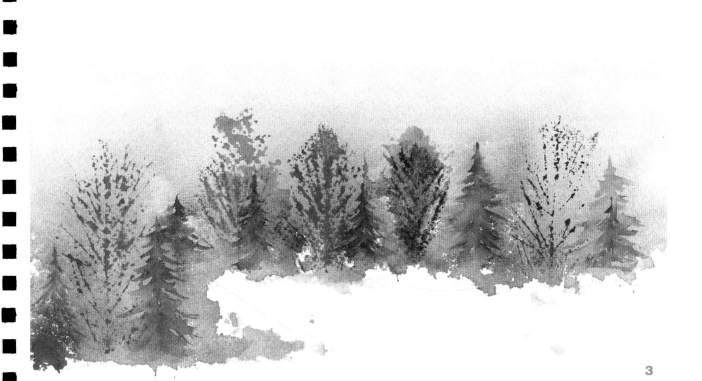

3

3 Fill Out the Forest With Painted Firs

Add fir trees to the forest with your round. Mix puddles of color of your choice from the mixtures listed in step 1. Paint the tree shapes with clean water firs. Then repaint them immediately with color in the brush, using at least two colors for each. Starting at the top of the tree, begin dabbing and stroking the brush out to the left, then back toward the middle of the tree; pause a second, then paint to the right and back toward the middle again. Work continuously in this manner until you reach the bottom of the tree. Each time you go back and forth, the boughs or limbs should get longer. Don't make the limbs directly opposite each other the same shape or size.

Paint the fir trees wherever there is an opening between stamped trees in the background area. Paint additional fir trees partially in front of some stamped trees in the foreground area to add depth to the forest. Place some small ones here and there near rocks and such if needed to complete your painting.

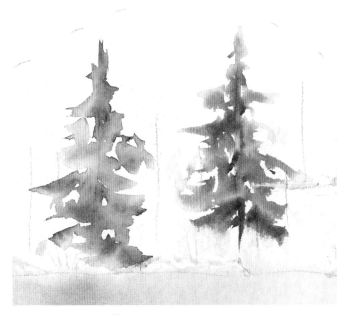

PAINTED FIR TREES

artist's comment

When you paint over the trees in color after painting them with clean water, don't worry about going over the exact shapes. Where the paint hits dry paper, the color will stay stationary; where it hits damp paper, the color will blur softly. The resulting hard and soft edges make better trees.

Autumn Trees at Sunset

CHRISTOPHER LEEPER

MEDIUM: *Acrylic*

COLORS: **Liquitex:** *Acra Red • Brilliant Blue • Burnt Sienna • Burnt Umber • Cadmium Red Light • Cadmium Yellow Medium • Cadmium Yellow Light • Dioxazine Purple • Indo Orange Red • Phthalo Blue • Phthalo Green • Raw Sienna • Titanium White • Ultramarine Blue (GS) • Yellow Orange Azo*

BRUSHES: *2-inch (51mm) flat • nos. 2, 4, 6 & 8 round*

OTHER SUPPLIES: *140-lb. (300gsm) hot-press watercolor paper • HB pencil*

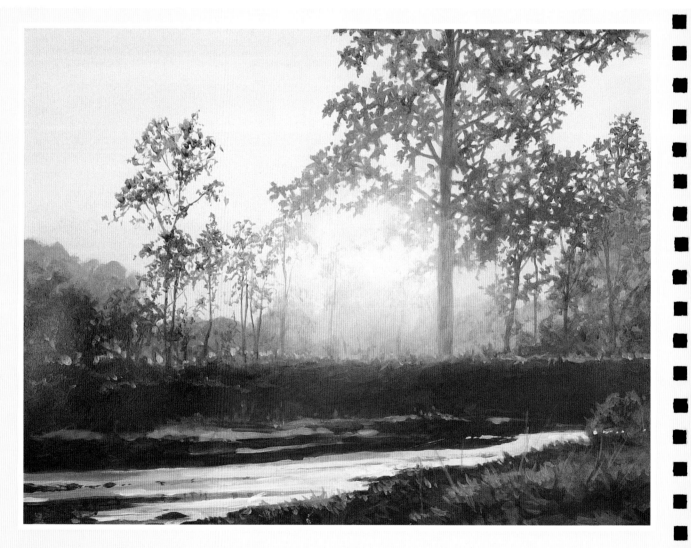

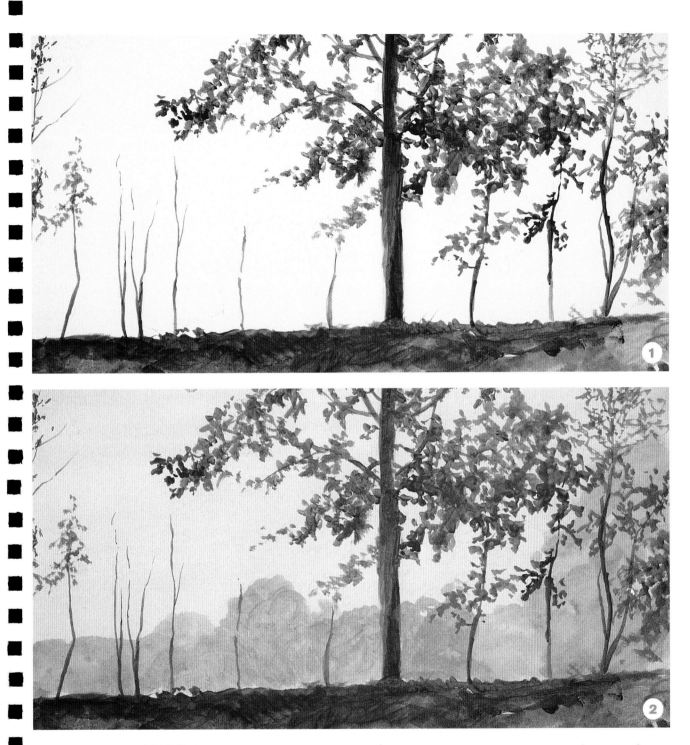

artist's comment

Backlit trees are an instant indicator (and a beautiful by-product) of a sunset or sunrise.

1 Paint the Darkest Values

Create a detailed drawing in pencil. Using nos. 4 and 6 rounds and a semi-transparent mixture of Dioxazine Purple + Ultramarine Blue + Burnt Umber + Indo Orange Red, paint the shapes that are to have the darkest value.

2 Paint the Background Trees and Begin the Sky

Using a no. 8 round, paint the background trees with a transparent mix of Yellow Orange Azo + Cadmium Yellow Medium+ Burnt Sienna. With a flat, paint a light transparent mix of Cadmium Yellow Light + Yellow Orange Azo over the sky area.

Autumn Trees at Sunset

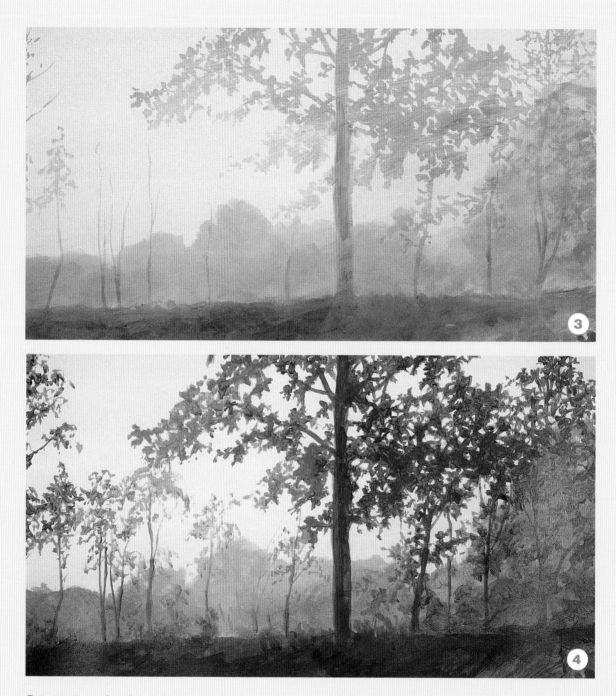

3 Paint Over the Sky and Trees

Wet the sky area with clean water and a flat. Then paint a semi-transparent mixture of Titanium White + a small amount of Phthalo Blue and Brilliant Blue. Along the horizon add a semi-transparent mixture of Titanium White + a touch of Raw Sienna. Brush back and forth until you have a smooth transition of color from top to bottom. Brush over the trees; their dark value will show through. You can re-establish their value and color later.

4 Re-establish the Trees

Use a no. 6 round to paint the background trees again with a semi-transparent layer of Yellow Orange Azo, Cadmium Yellow Medium and Burnt Sienna. Reestablish and develop further the silhouetted trees with nos. 2, 4 and 6 rounds. Darkest values are semi-opaque mixtures of Phthalo Green + Dioxazine Purple. Add Yellow Orange Azo, Indo Orange Red and Burnt Sienna to create warm-toned value areas in the trees and river bank.

5 Create Sunburst Effect
Establish the "sunburst" effect, using a no. 8 round and a semi-transparent mixture of Cadmium Yellow Light + Yellow Orange Azo. Mix a large amount of color and liberally apply it to the source of the sunburst. Use your fingers to blend this wash into the sky and the surrounding trees. Then paint a semi-transparent layer of Dioxazine Purple + Acra Red + Phthalo Green on the river bank.

6 Finish the Sunburst Effect and the Details

Use a no. 6 round to darken the background trees with a semi-transparent mixture of Burnt Sienna + Brilliant Blue + Yellow Orange Azo. Finish the sunburst effect by painting and finger-blending transparent layers of Cadmium Yellow Light and semi-opaque Titanium White. Allow each layer to dry before adding the next. Do this several times until you achieve the appropriate lighting effect. Add final details and highlights in the trees and on the river bank with a no. 2 round and touches of opaque Cadmium Yellow Medium, Cadmium Red Light and Indo Orange Red. For darkest details, use a semi-opaque mix of Indo Orange Red + Phthalo Green.

Wildflowers

CLAUDIA NICE

MEDIUM: *Watercolor*

COLORS: *Payne's Gray & Sap Green for the background • a few bright colors of your choice for the flowers and grass (Note: Color names may vary according to paint brands.)*

BRUSHES: *no. 4 round • larger brushes of your choice*

OTHER SUPPLIES: *pencil • MasquePen by Cruddas Innovations or other masking fluid and applicator • facial tissue • masking tape*

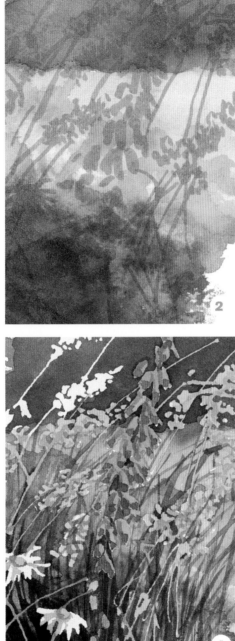

1 Draw and Mask
Loosely pencil in the flower shapes and a few grasses. Then mask them out. Masked areas are shown here in blue.

2 Paint the Background
On a damp (not wet) surface, lay in the background colors with mixtures of Payne's Gray and Sap Green. Don't overwork; the colors should be slightly muted in hue, but not muddy. Create areas of shadow and of sunlight. Dark shadow areas may need two coats. While the washes are moist, texture them by splashing on a few water drops (see mid green area on lower right) and by rolling a crumpled tissue through the paint to randomly blot up a few light areas (see light green area just above splashed area). Let dry completely.

3 Add Grasses
Stroke in a few grass blades using a no. 4 round and a variety of tones.

4 Remove Masking and Finish
Remove the masking by using masking tape rolled sticky-side out around your finger. Paint the revealed flower and grass shapes using lighter, brighter colors to complement the muted background. Flowers on the upper left have masking removed, but have not yet been painted.

artist's comment

Painting a patch of wildflowers like this tangle of foxglove, daisies and wild grasses is not as complicated as it appears. The key to the process is using masking fluid to block out the flowers and grasses so the background can be worked on with ease.

Sea Grasses

MARY K. ANDERSON

MEDIUM: *Oil*

COLORS: **Winsor & Newton:** *Blue Black • Burnt Sienna • Burnt Umber • Cadmium Orange • Cadmium Yellow • Cobalt Blue • Cobalt Violet • French Ultramarine • Indigo • Manganese Blue Hue • Raw Umber • Sap Green • Yellow Ochre*

BRUSHES: **Robert Simmons:** *nos. 2, 4 & 6 filbert •* **Pro Arte Connoisseur:** *nos. 2 & 12 sable round*

OTHER SUPPLIES: *4B, HB & 4H pencils • painting medium*

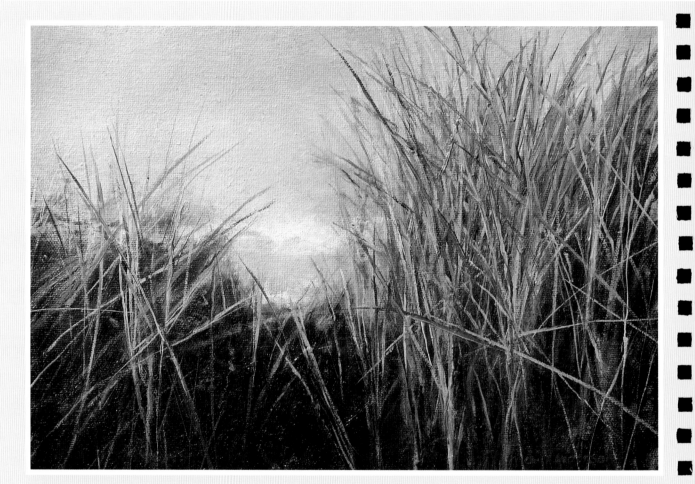

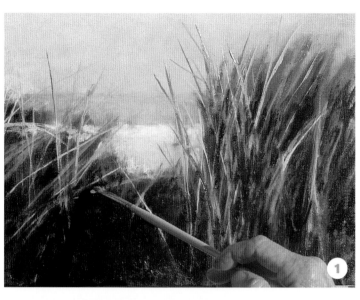

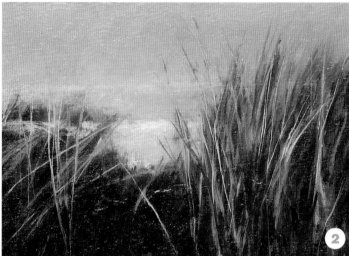

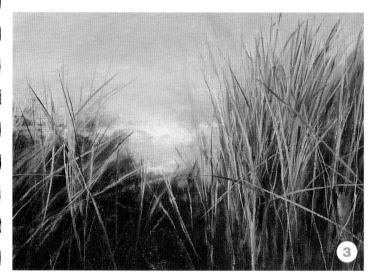

1 Apply Darkest Values

Begin with a value drawing of the grasses in pencil to help you see the patterns of light and dark, and to help you determine the structure of the grasses as a form. The medium values, or midtones, blend the light and dark values and add depth to the forms.

With your value drawing as your guide, apply the dark values first to establish overall light and dark patterns. Apply Raw Umber, Cobalt Blue, Blue Black, Cadmium Yellow, Burnt Sienna, French Ultramarine, Indigo and Burnt Umber with your filberts. The darks build the contrast and bring out the medium and light values to come.

2 Focus on the Midtones

Work the lighter values into the darker value, painting with Sap Green, Cadmium Yellow, Cobalt Violet, Cadmium Orange and Manganese Blue Hue. A little painting medium can help to blend and liquefy color. Work slowly to observe where the midtones should exist.

3 Refine the Grasses and Add More Color

Is the overall pattern of lights and darks interesting as a composition? Sharpen some edges and soften others. Blend strokes with your no. 2 round. Add more color where you think it's needed.

4 Glaze

(Refer to the painting on the opposite page.) Glazing can help bring out more warmth in your painting or cool things down. It will also add final touches for the composition. Where a touch of warmth is needed, apply a warm glaze of Yellow Ochre + a little Cobalt Blue + painting medium. For areas that need to be cooler, apply a cool glaze of Cobalt Blue + a little Yellow Ochre + painting medium. Apply these thinned paint mixtures with your no. 6 filbert or a no. 12 round.

artist's comment

When painting a subject such as this, seeing the patterns of value can be difficult. Don't get spotty; use a value drawing as your guide to keep your painting harmonized and on track.

Garden Flowers

SHARON BUONONATO

MEDIUM: *Acrylic*

COLORS: **DecoArt Americana:** *Asphaltum • Baby Blue • Black Plum • Buttermilk • Cadmium Yellow • Cherry Red • Hi-Lite Flesh • Midnite Blue • Olive Green • Plantation Pine • Pumpkin • Sapphire • Yellow Ochre •* **pale yellow mix:** *Buttermilk + Yellow Ochre (2:1)*

BRUSHES: *Sharon B's Crown brush • Sharon B's Blade brush • no. 3 round • no. 1 liner*

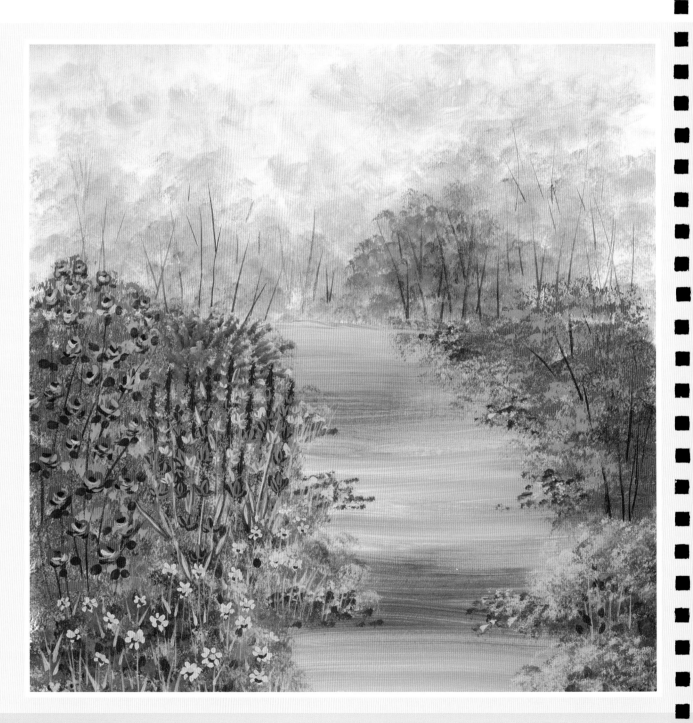

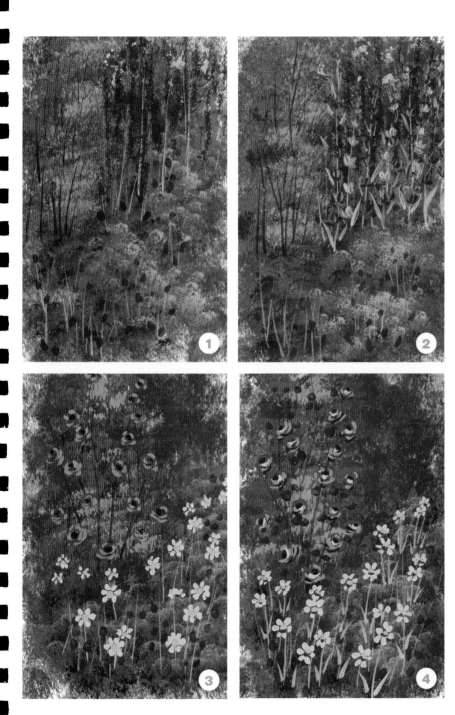

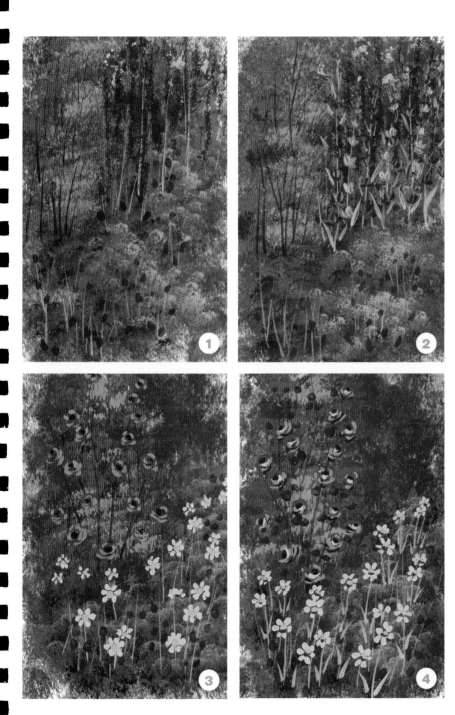

Paint small gladiolas (upper right), using the chisel edge of the Blade brush loaded with Cherry Red. Tap the color on vertically. Add Pumpkin-colored flowers in the same way. Paint Olive Green gladiola stems with the liner. Also add short stems to the blue flowers. Finish the blue flowers with small, one-stroke leaves, using Plantation Pine and the round.

2 Paint Large Gladiolas

Use the round to paint large three-stroke gladiolas on each stem. First paint Cherry Red blossoms and then Pumpkin. With the liner, add tiny over stokes of pale yellow mix on the Pumpkin flowers and Pumpkin on the Cherry Red flowers. Paint long Olive Green leaves off the stems.

3 Paint Large Roses and Daisies

Paint each large rose with bright pink (Cherry Red + Hi-Lite Flesh) and the round, making small, commalike strokes. Dab on a Black Plum throat with the tip of the round. Using the liner, overstroke each rose with tiny, light pink commas (adding more Hi-Lite Flesh to the pink mixture). Paint each daisy petal with Hi-Lite Flesh and the liner. Dot on a Cadmium Yellow center, using the round.

4 Finish the Roses and Daisies

Paint tiny strokes at the bottom of each rose, using Black Plum and the liner. Highlight across the bottom of the throats using Hi-Lite Flesh and the same type of strokes. Add one-stroke Evergreen leaves around the roses with the round. Paint a dash of Cherry Red at the base of each daisy center, using the liner. With the same brush, pull long Olive Green leaves off the stems.

1 Begin the Basic Flowers

Tap on bright pink roses with Cherry Red + Hi-Lite Flesh and the high corner of the Blade brush. (The rose bush is on the upper left.) Add light pink roses by using more Hi-Lite Flesh in the mix. Finish with Asphaltum linework branches, using the liner. Using the tip of the Crown brush, tap on Sapphire, Baby Blue and Midnite Blue flowers.

Water & Reflections

Water is so much more than an expanse of blue. You can choose a few colors or draw upon the entire spectrum to paint everything from a lazy stream to crashing surf. Reflections in water can be challenging to portray, but learning a few simple tips and techniques can give you pleasing results every time.

Breaking Ocean Waves

DIANE TRIERWEILER

MEDIUM: *Acrylic*

COLORS: **DecoArt Americana:** *Country Blue • Hi-lite Flesh • Indian Turquoise • Prussian Blue • Titanium White • Viridian Green • Winter Blue*

BRUSHES: **Loew-Cornell:** *Series 7300 no. 12 flat • Series 7400 ½-inch (13mm) angle • Series 798 ¾-inch (19mm) glazing • no. 2 fan*

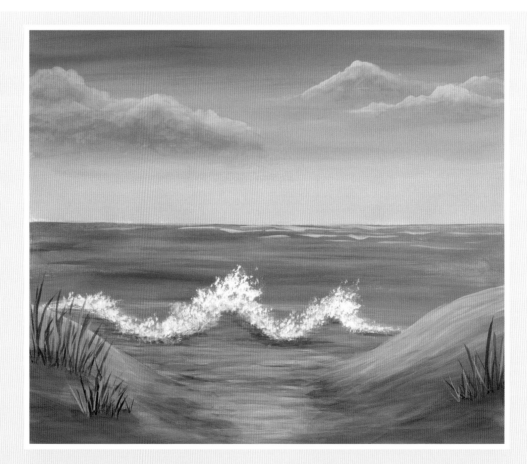

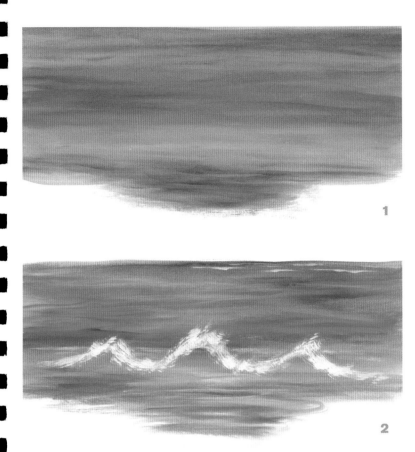

1 Paint the Water

Use the glazing brush to paint the water, working wet on wet. Begin with Winter Blue and pull the paint in horizontal strokes, gradually adding Prussian Blue. Blend in Viridian Green + a little Hi-lite Flesh where the breaking waves will be. Below this area, continue painting with Winter Blue and Prussian Blue.

2 Develop the Waves

Use the flat loaded with Hi-lite Flesh to place distant waves. Also, highlight here and there throughout the water with the same color. Use the fan brush with Titanium White to "smear" on wave shapes. Add a tint of Viridian Green throughout the water.

3 Stipple Wave Foam

Add tints of Country Blue throughout the water. Load the corner of the fan brush with Titanium White and begin to stipple foam on the waves.

4 Add More Foam and Shading

Corner-load the angle brush with Prussian Blue and shade underneath the waves here and there. Highlight the top of the largest Viridian Green area with a little Titanium White. Add tints of Indian Turquoise throughout the water. Add more foam sprays of Titanium White to the breaking waves.

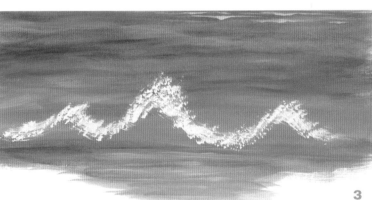

artist's comment

Stippling is a method of applying paint by pushing the end of your brush onto the paper and then pulling up in fast strokes. It's the perfect technique for portraying the foaming action of breaking waves.

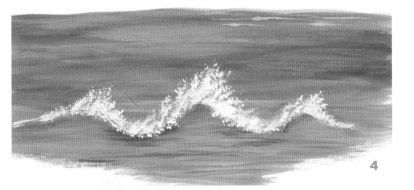

Underwater Stones

CLAUDIA NICE

MEDIUM: *Watercolor*

COLORS: *Burnt Sienna • Sepia • Yellow Ochre (Note: Color names may vary according to paint brands.)*

BRUSHES: *¼-inch (6mm) stroke • no. 4 round*

OTHER SUPPLIES: *masking fluid or tape • cellular (kitchen) sponge (preferably one with many oval-shaped holes)*

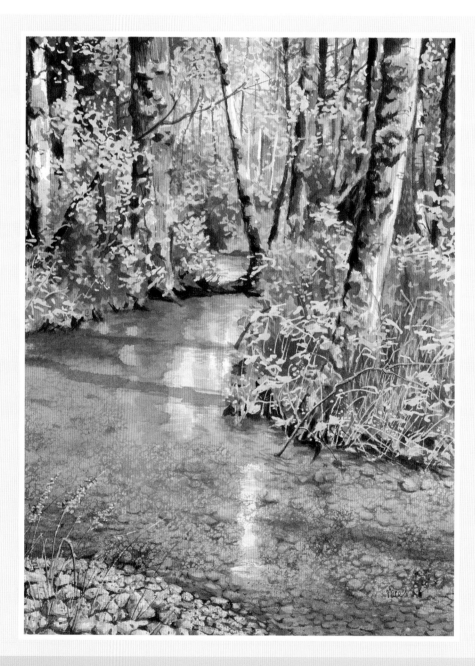

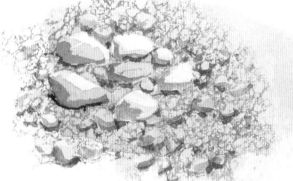

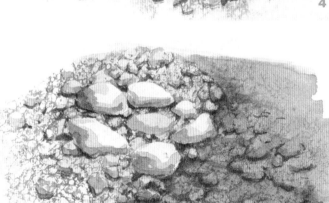

artist's comment

Creating the textured look of river stones using a common kitchen sponge is much easier than painting individual stones—and the results are more realistic. Add some pale washes selected from the palette used in the surrounding scene to help tie the rocks into your landscape.

1 Apply Base Wash and Masking

Use a stroke brush to apply a warm gray wash of Burnt Sienna + Yellow Ochre + a hint of Sepia over the stony area. Make very pale with lots of water. Let dry. Mask large stone areas (shown in blue) with masking fluid or bits of tape.

2 Stamp on the Stones

Paint the bottom of the dry sponge with a dark wash of Sepia and stamp it onto the gravel area. Let dry.

3 Develop the Stones and Crevices Underneath

Remove masking. With a round and Sepia, darken

crevices under a few stones. Tint some rocks with muted brown washes (same basic color mix as background). For variety, make another mix with a bit more Sepia or Burnt Sienna.

4 Add Shading

Let dry. Then use the same brush and mix to darken the shadow side of the larger stones with a second layer of color.

5 Submerge Some of the Gravel

Brush the underwater gravel with a wash mixture of Burnt Sienna + Yellow Ochre + a touch of Sepia. If the underwater area is large, switch back to the stroke brush.

Riverbank

KERRY TROUT & JUDY KREBS

MEDIUM: *Acrylic*

COLORS: **DecoArt Americana:** *Bittersweet Chocolate • Blue Haze • Burnt Umber • Graphite • Light Buttermilk • Neutral Grey • Prussian Blue • Titanium Snow White • Wedgewood Blue*

BRUSHES: **Loew-Cornell:** *Series 7300 nos. 6, 8 & 14 flat shader • Series 7500 no. 12 filbert • Series 7120 ½-inch (13mm) rake • Series 7350 no. 1 liner*

OTHER SUPPLIES: *gesso • clear glaze*

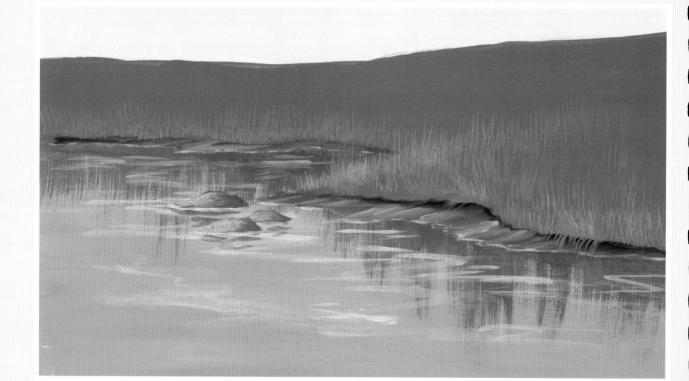

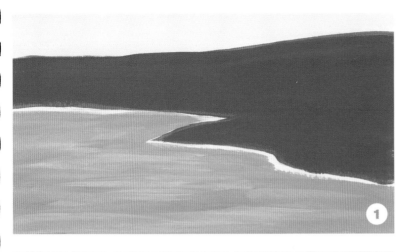

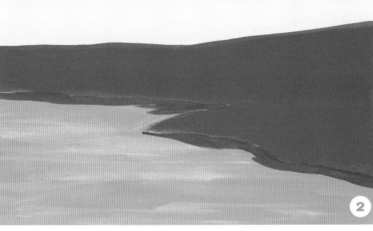

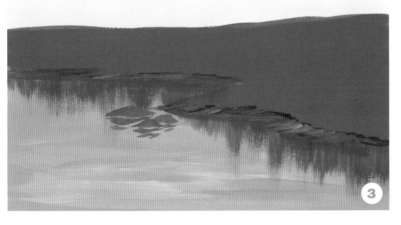

2 Paint Along the Bank

Apply a line of green (darker than the grass) at the edge of the water, just below the bank. Make it a thinner line at jutting points of land.

3 Develop the Bank, Reflections and Rocks

While still wet, use the filbert to pull the green paint straight down. Add a few areas of brown and pull down again, blending into the green. This will suggest the reflection of the grass and dirt bank. Add a line of Burnt Umber just above the water line for a dirt bank. Using a no. 8 flat shader, pull the strokes at a downward angle toward and into the water. While wet, add some Light Buttermilk to your brush and go over the brown areas to vary the texture and light on the dirt bank. Make this bank larger as you near the foreground.

Add the tops of rocks in the water with a no. 6 flat shader and Neutral Grey. Add just a touch of Graphite to darken the Neutral Grey. Then apply the reflection in the water just below the rocks.

4 Add Grass, Shading and Swirls

Refer to the final step shown on the opposite page. Float Bittersweet Chocolate at the top of the bank in a few areas to suggest the shadow of the overhanging bank. With the rake brush, add blades of grass to the edges of the bank, and have some overhang the bank.

Mix Titanium Snow White + clear glaze (1:1), and use the no. 14 flat shader to wipe this mix across the water in natural, swirling lines. Use thinned Titanium Snow White and the liner to paint additional smaller, thinner lines across the surface of the water. Also add very thin lines of white at the water's edge and at the base of each rock.

1 Paint the Water

Paint the water and riverbank after the background is done. Here you see everything based in for demonstration purposes. Apply a coat of gesso over the water area. While the gesso is wet, use a no. 14 flat shader to apply shades of Wedgewood Blue, Blue Haze and Prussian Blue, then blend into the gesso using horizontal strokes. Don't overblend; allow some white streaks to show through. Let dry.

artist's comment

Lines not only add texture to the water's surface, but they show the direction and activity level of the water.

Surf Crashing on Rocks

CHUCK LONG

MEDIUM: *Watercolor*

COLORS: **Winsor & Newton:** *Burnt Sienna • French Ultramarine • Permanent Sap Green • Raw Sienna • Winsor Blue (Red Shade) • Winsor Violet*

BRUSHES: *1-inch (25mm) flat • nos. 8 & 12 round*

OTHER SUPPLIES: *11" x 15" (28cm x 38cm) 300-lb. (640gsm) cold-press watercolor paper • HB pencil • kneaded eraser*

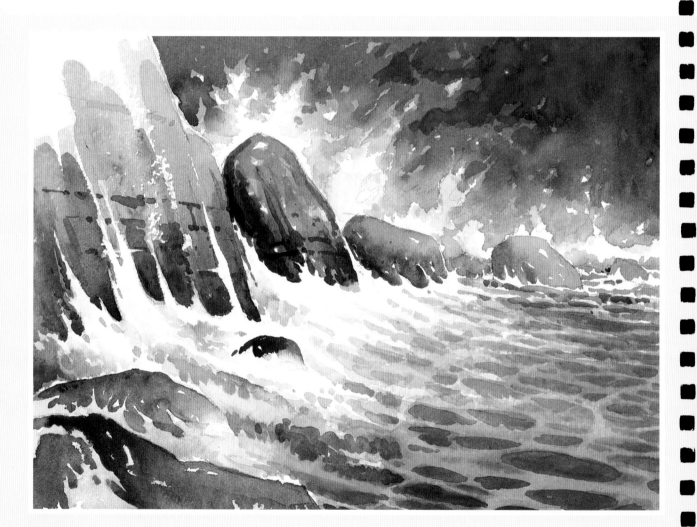

1 Paint the Sky

After making a rough pencil drawing, wet the sky area with clean water. Then, working wet-in-wet with your flat, flow a mixture of French Ultramarine + Winsor Blue + Permanent Sap Green into the sky. After this dries, paint the darker areas in the sky. Using a no. 12 round filled with water, soften some edges of the splash.

2 Paint the Rocks

Rough in the rocks using the no. 12 round and mixtures of French Ultramarine, Raw Sienna and Burnt Sienna. Accent splashes and make the rocks recede into the water.

3 Begin the Water

Paint the water with French Ultramarine and Permanent Sap Green and a no. 12 round. Indicate the direction of rush onto the rocks, working in lighter values first, then darker, saving the whites for strong splashes.

4 Strengthen the Water

(Refer to the painting on the opposite page.) Still using the same colors and round, add darker values in the water for strength and depth. Add texture to the rocks using French Ultramarine, Burnt Sienna and Winsor Violet in a no. 8 round.

flip ahead ⇨

Turn to pages 114-115 to practice painting water that calmly moves about rocks.

Winter Stream

MARGARET ROSEMAN

MEDIUM: *Watercolor*

COLORS: **Daler-Rowney:** *Quinacridone Magenta* • **Holbein:** *Indian Yellow* • *Manganese Blue* • **Winsor & Newton:** *French Ultramarine* • *Raw Umber*

BRUSHES: *2-inch (51mm) hake • 1-inch (25mm) flat gold sable • no. 5 round gold sable • no. 4 rigger*

OTHER SUPPLIES: *140-lb. (300gsm) cold-press watercolor paper • B pencil • masking tape*

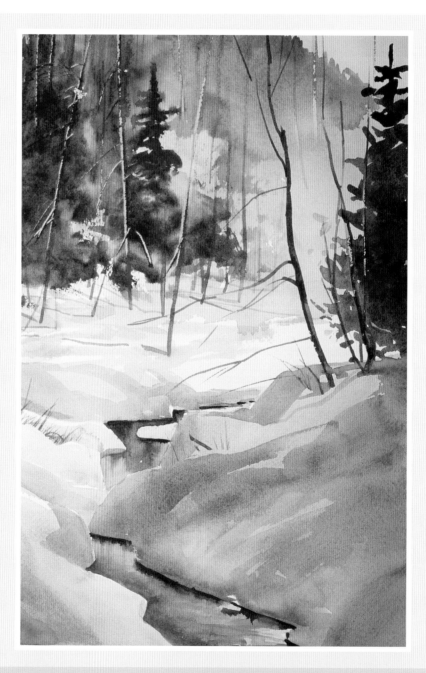

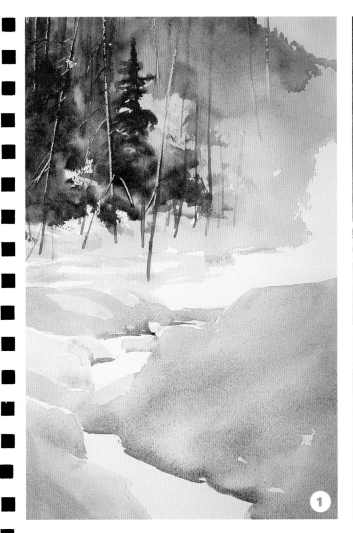

1 Paint the Snow Banks

After penciling in the stream, premoisten the snow banks on either side with a hake brush. Starting with Manganese Blue in the distance, paint a few horizontal strokes with the flat. Change color to a wash of French Ultramarine and apply the paint to the snow mounds along the stream, following the contour of each form.

While the large mass on the right is still wet, drop in a mix of Quinacridone Magenta + French Ultramarine as well as a little Raw Umber. Allow the colors to mix freely without further brushing. Using the round and a fairly rich mix of Quinacridone Magenta + a little French Ultramarine run a thin edge along the base of the snow mound as it touches the edge of the stream.

2 Paint Cast Shadows

Indicate a few large cast shadows (from the trees) along the snow mounds with an application of French Ultramarine, using the flat.

artist's comment

Earlier in the book, you learned how to paint tall pines in watercolor (see pages 40-41). To paint young bare trees like the ones in this demonstration, use a rigger to draw graceful, graphic lines. Drag a cut-up credit card where the trees cross a dark area (such as the mass of background pines shown here) to link up with the painted lines.

Winter Stream

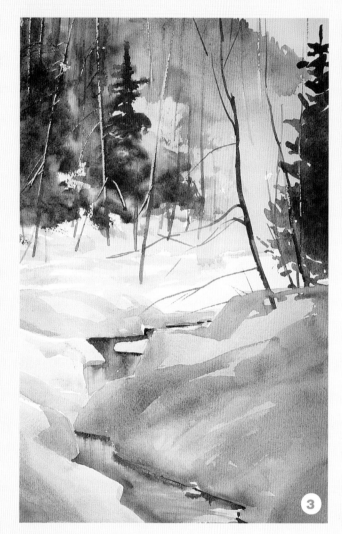

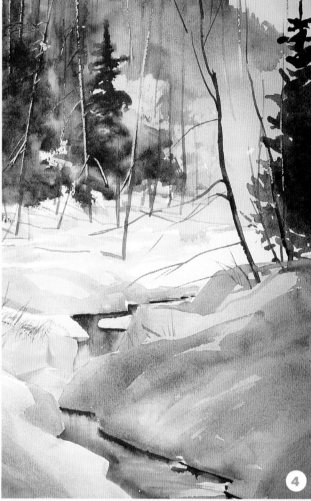

3 Paint the Stream

Apply a light wash of Raw Umber to the distant part of the stream. While the paint is still damp, drop in a vertical application of green made up of Raw Umber + Indian Yellow + French Ultramarine. This will suggest the reflection of the distant pines. Begin the foreground part of the stream with a wash of Raw Umber + a touch of Quinacridone Magenta that quickly changes to Manganese Blue and French Ultramarine as it moves to the foreground. With the round, apply an additional dark of Quinacridone Magenta + French Ultramarine along the bank as it meets the water.

4 Add Snow Bank Details and Cast Shadows

Once all the areas are dry, manipulate masking tape to curve atop a snow mound. Using the rigger and several values of a mix of Raw Umber + French Ultramarine Blue, paint a few tapering grasses, starting the brushstroke on the masking tape and lifting your hand as you finish the stroke. Repeat the masking-tape process on the right side of the composition, making sure to vary the brushstrokes and the overall detail.

With the round and a range of light to midtone French Ultramarine, paint the cast shadows of the bare trees in the middle ground. Have these lines curve and slant to suggest the direction of the light source and the contour of the snow-covered ground.

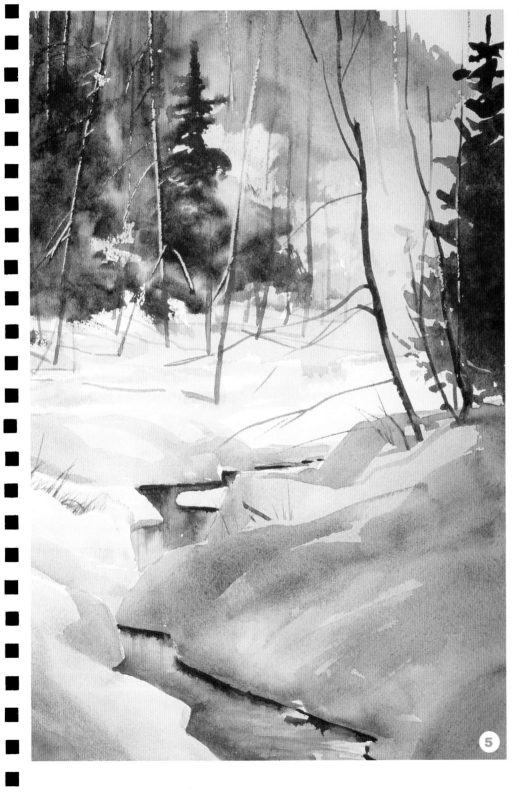

5 Finish

Remove the masking tape from the snow mound and finish any last details.

5

Waterfalls

LIAN ZHEN

MEDIUM: *Watercolor*

COLORS: *Antwerp Blue • Azo Yellow • Permanent Red (Note: Color names may vary according to paint brands.)*

BRUSHES: *¾-inch (19mm) flat • 1½-inch (38mm) flat • nos. 4 & 8 round • old brush for applying masking*

OTHER SUPPLIES: *140-lb. (300gsm) cold-press watercolor paper, 14½" x 20½" (37cm x 52 cm) • no. 2 pencil • masking fluid • rubber cement pickup (optional) • spray bottle • paper towels*

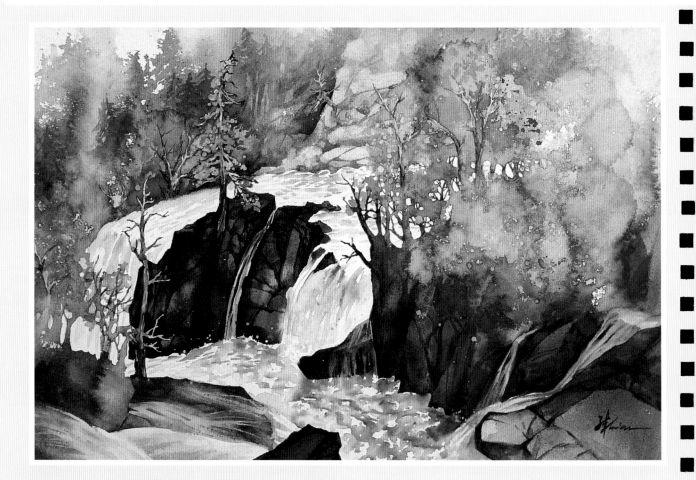

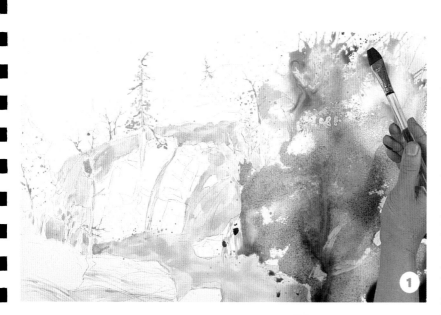

1 Apply Mask and Pour First Colors

Sketch the landscape on the paper with a no. 2 pencil. Apply masking fluid on the water and trees in the foreground and middle ground. Let dry.

Use a spray bottle to wet the paper slightly. Leave the upper-left corner dry to allow for a white background there. At the tree area on the middle right of the painting, pour on Azo Yellow first, then Antwerp Blue. At the rock area on the lower right, pour on Antwerp Blue and then Permanent Red. Let the colors blend. At the upper right, use your mouth to blow the fluid colors upward, creating the impression of distant treetops. Use the smaller flat to touch up.

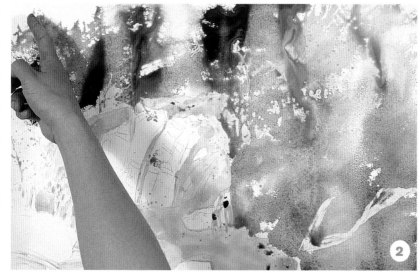

2 Continue Pouring Color for Trees and Rocks

Continue the pouring at the upper middle and left side of the painting: pour Antwerp Blue and Permanent Red for the rocks; pour Azo Yellow and Antwerp Blue for the trees. Allow the colors to flow into each other freely. Use your fingers to drag the fluid paint to form the treetops at the upper left.

3 Let the Colors Flow Down

Tilt the top part of the painting upward to let the colors flow down your paper. Only tilt the painting in one direction, otherwise the fluid colors may mix with each other too much and appear muddy. Use paper towels to remove excess color.

artist's comment

Try pouring on color if you're bored with your standard painting techniques. The unpredictability of it is liberating, and it turns out fantastic results that you'd be hard-pressed to achieve with basic brushwork.

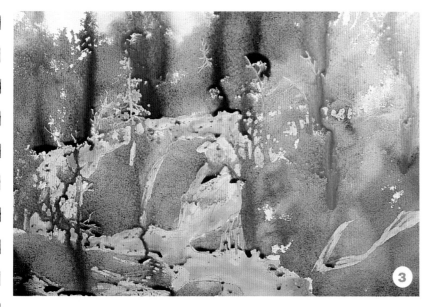

Waterfalls

4 Develop the Rocks and Trees

While the painting is still wet, use the larger flat to mix varying amounts of thick Antwerp Blue + thick Permanent Red for a dark purple and a dark blue on your palette. Then paint the foreground and middle-ground rocks. Also, at the upper-middle area, use a dry paper towel to lift some color to form rock shapes.

The colors on the painting are about 70 percent dry now. Dip the larger flat in fluid Azo Yellow and spatter it on the trees. The tree colors become more yellowish and the backruns suggest some tree shapes.

5 Add Rock Texture and Remove Masking

Use a no. 4 round to paint the cracks of the rocks. In areas of darker color, make darker lines with a mixture of thick Antwerp Blue + thick Permanent Red. In the lighter areas, use a lighter mixture of these colors. Wait for the colors to dry completely before removing the masking.

6 Paint the Masked Trees and Lower Falls

Fill in colors where the whites had been saved on the trees. Apply Azo Yellow first, then Antwerp Blue or Permanent Red depending on the colors of the woods. To create the falls at the lower left and lower right, use a wet paper towel to lift up and drag color over the waters. You are essentially using the towel to paint.

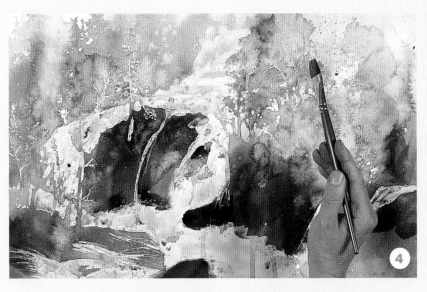

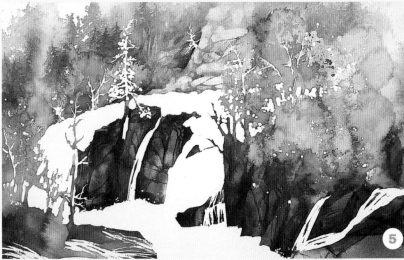

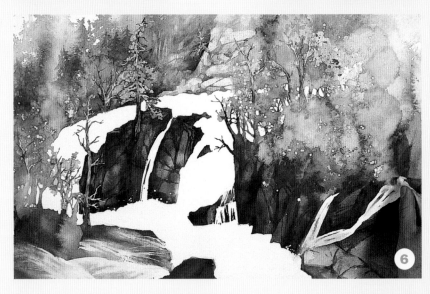

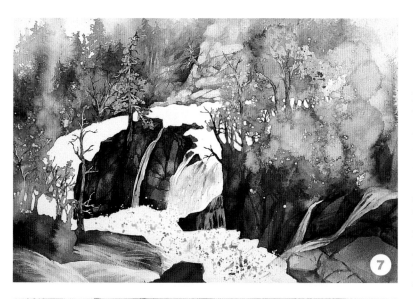

7 Work on the Lower Middle Falls
Use your rounds to paint the waterfall at the middle. First, wet most of the waters with the no. 8 round. Then use the no. 4 round to paint light Azo Yellow and Antwerp Blue on the moistened areas. Immediately charge with light Permanent Red. For the large waterfall area on the bottom, use the no. 8 round to spatter water and the three fluid colors onto it.

8 Finish the Lower Middle Falls
Wet the no. 8 round and use it to drag the fluid-spattered colors into each other. Then apply dark blue (a mixture of thick Antwerp Blue + a little thick Permanent Red) at the water below the rocks, suggesting the reflections of the dark blue rocks.

9 Paint the Remaining Falls
Paint the water at the upper-middle area and left side with the same method of spattering and dragging color described in steps 7 and 8.

flip ahead ⟹

Turn to pages 114-115 to practice a different technique for painting falling water.

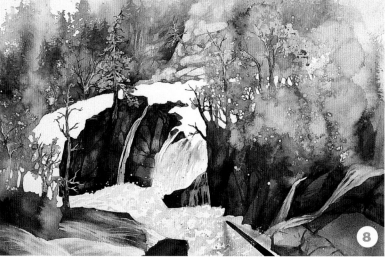

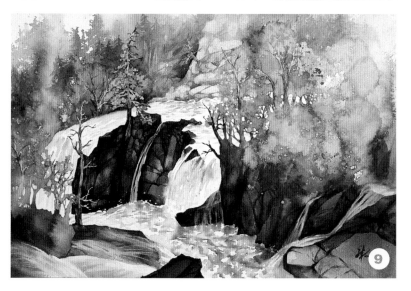

Reflections on Still Water

KITTY GORRELL

MEDIUM: *Oil*

COLORS: *Burnt Sienna • Naples Yellow • Perinone Orange • Phthalo Blue • Titanium White •* **autumn green mix:** *Burnt Sienna + Phthalo Blue (3:1) (Note: Color names may vary according to paint brands.)*

BRUSHES: *flat or wash for priming • ½-inch (13mm) bristle flat • no. 8 royal sable filbert • no. 4 royal sable flat*

OTHER SUPPLIES: *clear medium (optional; can be added to the oils to help the paint move on your canvas) • orange acrylic paint*

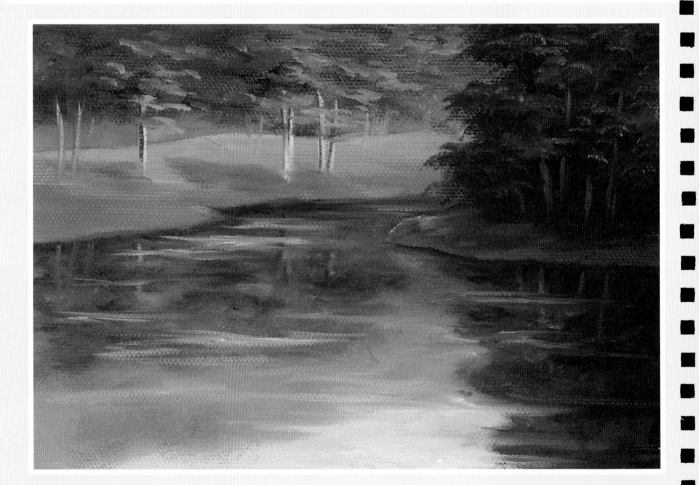

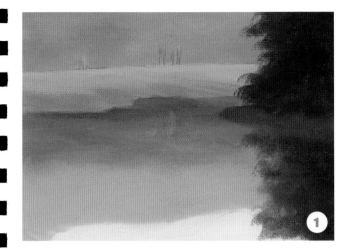

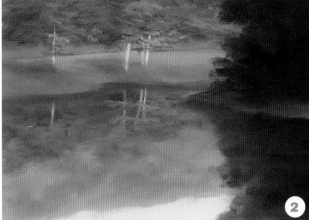

1 Base Paint the Reflections

Prime your painting surface with a midvalue of acrylic orange paint to establish a clean, crisp color as a base value. Using the bristle flat, brush mix Titanium White + autumn green mix for a midvalue gray-green. With this color, base in the distant background all the way to the ground line. Reflect this color in the water, a little darker in the shadow areas and lighter toward the foreground and center of the stream. Base paint the land in the background with Naples Yellow + Titanium White. Paint the sky reflection in the foreground water with Titanium White + a touch of Phthalo Blue.

Base paint the closer bank with lean amounts of Burnt Sienna + Perinone Orange. Base paint the closer grove of trees with autumn green mix, and paint the reflection only slightly lighter in the water.

2 Develop the Sycamores on Land and in Reflection

Much of the foliage on the sycamore trees in the background will be added to the water reflections, but with muted detail. To vary the autumn green mix and give it more interest, add touches of additional Burnt Sienna or Phthalo Blue, Perinone Orange or Naples Yellow. Trunks are a "dirty white" made by adding just a touch of autumn green mix to Titanium White. When reflecting these trunks into the water, the hue should be just a little less white.

3 Develop the Closer Grove and Detail the Reflections

Refer to the painting on the opposite page. Highlight the closer grove of trees with Naples Yellow in the warm areas, going to Naples Yellow + a touch of Phthalo Blue for a cooler highlight in the shadowed areas. Do not overwork. Reflect the highlights sparingly in the water. Add trunks with a dull mixture of Burnt Sienna + Naples Yellow. Add suggestions of these trunks in the water.

Place shimmers in the water with light strokes of the royal sable flat. The water is calm, so all shimmers should be relatively parallel with the bottom edge of the canvas. Shimmers in the sunny areas are very light values of the colors already in the water. This is easily achieved by softening some Titanium White with a drop or two of clear medium and then stroking in the shimmers. As the white cuts across the colors already in the water, the lighter values appear automatically. Shimmers in the shadow areas are cool values made with the sky blue mix from step 1 and a touch of the colors already reflected in the water.

artist's comment

Here are a few tips for painting reflections:
- Place the reflecting colors in the water as you work with those colors on the land, trees, sky, etc. Watch placement to duplicate the subject being reflected.
- Lay the colors in with lean amounts of paint and very little blending.
- Water along the shore line usually has a little darker value.
- The final details in reflections are what make them so appealing in a painting, but be careful not to overwork.

Reflections on Moving Water

TERRENCE L. TSEH

MEDIUM: *Acrylic*

COLORS: *Bright Yellow • Burnt Sienna • Cadmium Red Medium • Cerulean Blue • Dark Brown • Dark Green • Pink • Raw Sienna • Titanium White • Ultramarine Blue • Violet (Note: Color names may vary according to paint brands.)*

OTHER SUPPLIES: *cellular (kitchen) sponge*

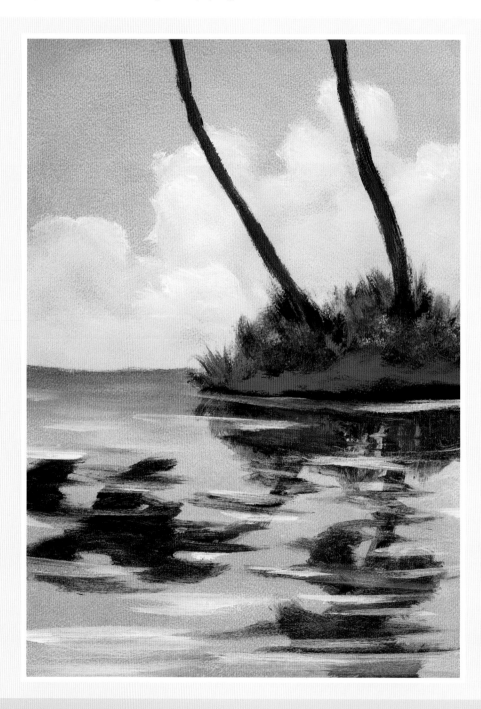

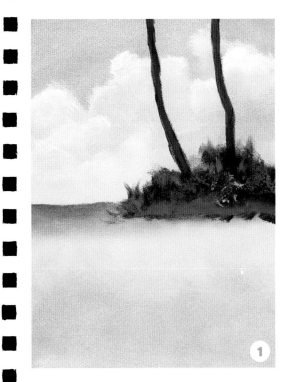

1 Paint the Land Mass

Apply an all-over wash of Cerulean Blue. Paint to completion the land mass and its individual elements.

2 Paint the Mirror Image

Using the colors of the land mass and its elements, mirror the image onto the water area. In the perspective of looking over the water, the tree trunks appear shorter. Because of this, you will paint the reflected trees shorter and include the reflected palm tree tops, even though the tops on land are out of the picture plane.

3 Move the Colors in the Reflections

While the paint is still wet, drag down the reflected colors close to the upper land mass. Using the clean edge of the sponge, spread some reflected areas in short horizontal strokes.

4 Finish the Water's Surface

Refer to the final step shown on the opposite page. Finish the surface of the water by applying Titanium White in varying horizontal strokes and paint thicknesses.

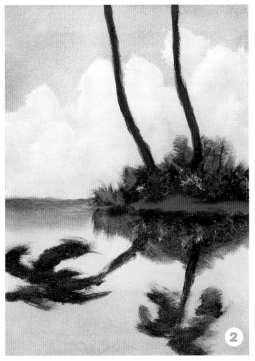

artist's comment

You can paint this scene with nothing more than a household sponge. The technique is fast and easy, and is especially helpful when painting murals.

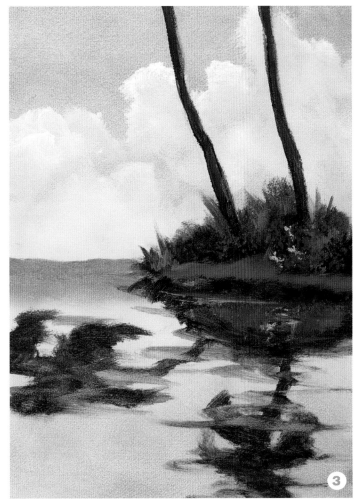

Lakeside Reflections

BETTY CARR

MEDIUM: *Watercolor*

COLORS: *Antwerp Blue • Burnt Sienna • Cadmium Orange • Cadmium Red Light • Cadmium Yellow • Cadmium Yellow Pale • Cobalt Blue • Cobalt Violet • Indian Yellow • Manganese Blue • Permanent Rose • Quinacridone Burnt Orange • Raw Sienna • Sap Green • Thio Violet • Ultramarine Blue • Viridian • Winsor Red (Note: Color names may vary according to paint brands.)*

BRUSHES: *kolinsky sable nos. 10, 6 & 4• rigger • 1-inch (25mm) flat • stiff-bristled short hair (Note: Most painting is done with a no. 10 round. Use smaller rounds and rigger for final touches. Use flat and stiff-bristle brush where instructed.)*

OTHER SUPPLIES: *140-lb. (300gsm) cold-press watercolor paper, stretched • salt • paper towels • craft knife*

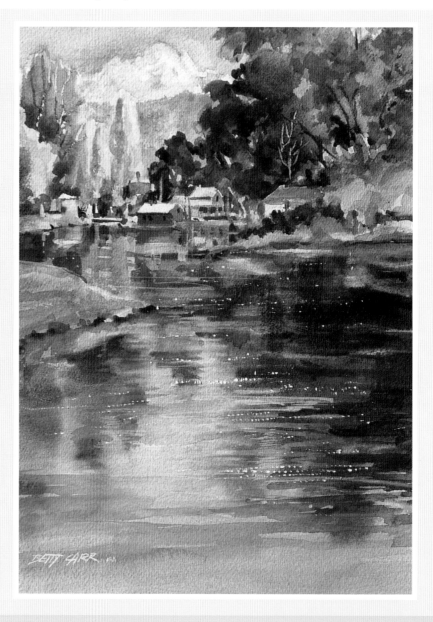

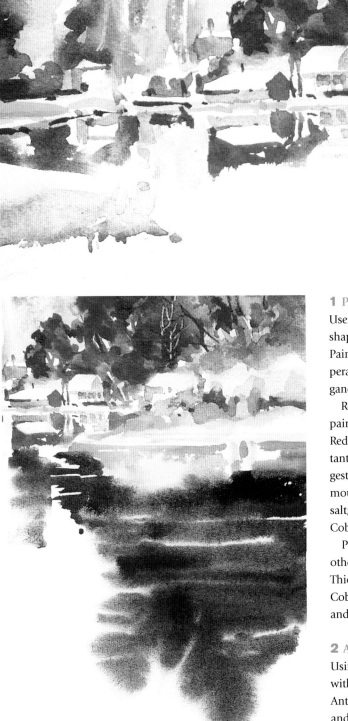

1 Paint the Shoreline and Begin the Reflections
Use Burnt Sienna + Antwerp Blue to establish dark tree shapes and Indian Yellow + Cobalt Blue for the light trees. Paint additional warm bushes, and vary the sizes and temperatures of foliage by adding Cadmium Yellow + Manganese Blue shapes.

Refer to the finished painting on the opposite page when painting the mountain and sky. With a mixture of Winsor Red + Ultramarine Blue + Cadmium Orange, paint the distant mountain, leaving the paper unpainted in areas to suggest snow peaks. Use the same mixture to create the closer mountain range. While slightly damp, sprinkle touches of salt; this will suggest trees when dry. Paint the sky using Cobalt Blue.

Paint small suggestions of boats, cabins, barns, poles and other waterfront shapes using Cadmium Red Light, Viridian, Thio Violet, Quinacridone Burnt Orange, Raw Sienna and Cobalt Violet. Mirror some of these structures in the water, and surround these reflections with Ultramarine Blue.

2 Add Wet-in-Wet Reflections
Using the flat, wet the entire lower portion of the painting with clean water. When the paper is semi-moist, drop in Antwerp Blue, Quinacridone Burnt Orange, Permanent Rose and Cadmium Yellow Pale. Suggest horizontal strokes, but let the paint do its thing without overworking. Let dry.

Lakeside Reflections

3 Develop the Shoreline Reflections

Re-wet the water area near the shoreline and continue dropping in reflections using Indian Yellow, Raw Sienna and Sap Green. Add touches of violet with Ultramarine Blue + Permanent Rose. Glaze the shoreline on the left using Raw Sienna.

4 Suggest the Surface of the Water

Dampen a stiff, short-hair brush and drag it across the dried, dark reflection to lift suggestive horizontal lines. Dab the surface of the painting with a paper towel to help lift the color.

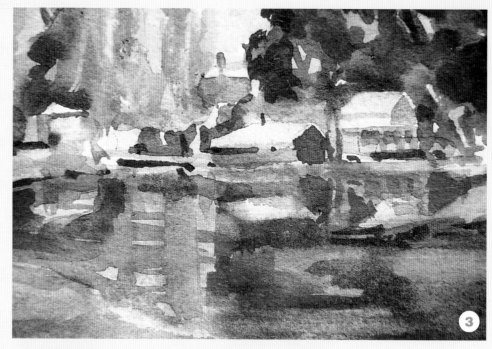

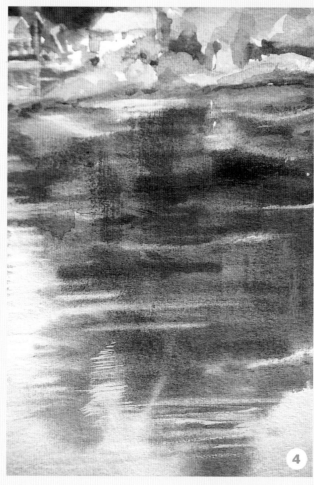

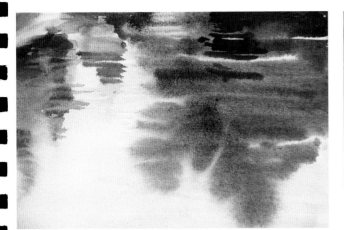

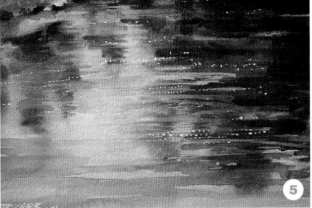

5 Develop the Main Reflections

Add Cobalt Blue and Ultramarine Blue, gradating the mixture from light to dark. On a wet surface, fill in the sky reflections between the tree reflections in the water, and paint over some of the previously lifted horizontal lines. Let this dry.

Using a craft knife, skip the point of the blade along the surface of the water to "pick" glittering lights off the dark reflection, suggesting sparkle. *Note:* The first image shows this area of the painting before development (including the lifting in step 4), so you can see what a difference the details make.

FINISHED PAINTING

The softened edges of the reflections are a great complement to the hard edges along the shore.

flip ahead ⇨

Turn to pages 105 for more instruction on painting lakeside reflections.

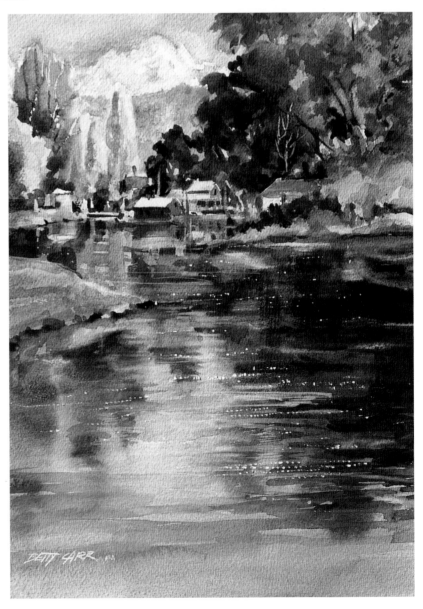

Reflections at High Noon

KATHI HANSON

MEDIUM: *Watercolor*

COLORS: **Winsor & Newton:** *Antwerp Blue • Aureolin • Cadmium Orange • Cobalt Blue • French Ultramarine • Payne's Gray • Winsor Red • Winsor Yellow*

BRUSHES: **Silver Brush Limited:** *Series 1511S Silverwhite 1-inch (25mm) stroke brush • Series 3000S Black Velvet no. 8 round (both brushes part of Kathi Hanson's Basic Watercolor Set)*
Generic: *scrubber brush (optional) • old brush of your choice, for applying masking*

OTHER SUPPLIES: *300-lb. (640gsm) cold-press watercolor paper • pencil • masking fluid • rubber cement pickup (optional) • toothbrush • spray bottle (optional) • facial tissues*

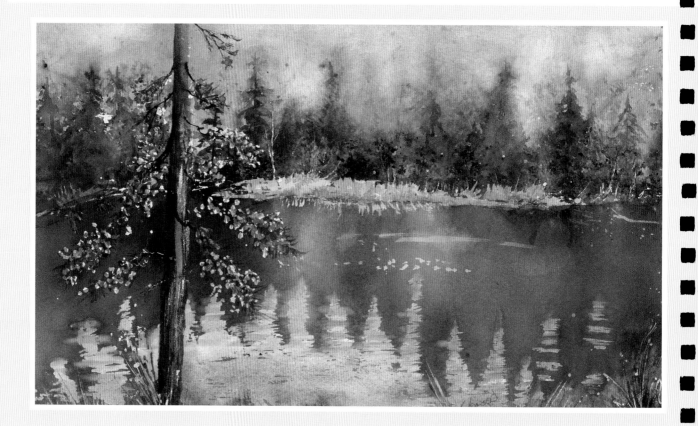

1 Save a Few Areas With Masking

After making a drawing, apply masking fluid to the tree trunk and leaves positioned in the water area, the reed and grasses that are visible through the water, and the far-bank reed reflections. Let dry thoroughly before you begin painting.

2 Paint the Water

Load the no. 8 round with a medium-value of Cobalt Blue. Stroke in the blue water areas, starting on the left side of the tree and continuing to the right. Start applying the color at the far shoreline first and then work up to the foreground shore edge. As soon as all the water has been painted, load the brush with French Ultramarine and stroke some darker blue on top of the Cobalt next to the tree and in a few spots near the shoreline. The colors will softly blend because the first color is still damp.

artist's comment

Reflections are different depending on the time of day. Evening reflections are muted in color, and the shapes seen in the water are diffused. During the day, especially at midday (noon to 3:00), the color of the water is bright and the shapes reflected in the water are tight, giving the appearance of bold contrast where the water meets the tree shapes.

Reflections at High Noon

3 Apply Masking to the Water
Once the paper is dry, apply masking fluid to the blue water areas. Take your time and be precise; wherever you place the masking fluid will leave an obvious shape when it is removed. As you apply the masking in the large open-water area, leave a few tiny areas unmasked. As the painting progresses, we will put some green reflected colors in those areas. Let the masking dry thoroughly before continuing.

4 Lay In the Reflection Colors
All reflection colors will be laid in at once and quickly, so have large puddles of all mixtures ready to go and placed left to right in the order listed. Pre-wet the paper to keep the paints fluid once they are applied so they can be manipulated further in step 5. Using the stroke brush, apply these color mixes, working from left to right:

Mix 1 = Payne's Gray + Antwerp Blue + French Ultramarine

Mix 2 = Mix 1 + more Payne's Gray

Mix 3 = French Ultramarine + Winsor Yellow

Mix 4 = Cadmium Orange

Mix 5 = Winsor Yellow

Mix 6 = Cobalt Blue + Winsor Yellow

Mix 7 = Payne's Gray + Antwerp Blue + Aureolin

(Place a stroke of Mix 3, then Mix 5, then Mix 4 again before applying the next two mixes.)

Mix 8 = Mix 7 + more Payne's Gray

Mix 9 = Winsor Red + French Ultramarine

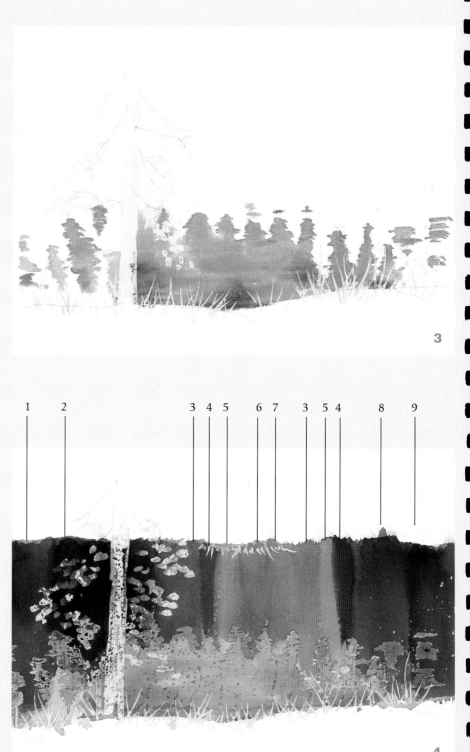

5

6

5 Blend Colors

Immediately pick up the paper and tap the left edge on the table. The colors should start blending into each other from right to left, making the initial distinct stripes of color disappear. If the colors don't move easily, take a spray bottle and lightly spray the right edge of the paper with water. Let the colors pass through each other only once to avoid muddied, over-mixed color. Tilt the paper back and forth slightly if any colors need additional blending. Tap the bottom edge of the paper on your table, allowing the greens to roll over the masked water area and fill in any unmasked spots. Lay the paper flat while it dries, and then remove the masking fluid. *Note:* The colors will appear lighter when the painting dries due to the water added during blending.

6 Soften the Reflections

Some, but not all, of the reflection edges need to be slightly blurred into the water. Blend only a little, since reflections during the day are more clearly defined. Do this by running a damp toothbrush back and forth between the colors on either side of the edge a few times and then blotting the area with a tissue. In tight areas, you can use a damp scrubber brush; however, I prefer to use the toothbrush whenever possible as it leaves more irregular shapes. Also run the toothbrush over the small areas of green in the blue water area and blot if needed.

Rocks & Land

Rocks can add texture and color to just about any landscape. You can use them to direct the eye toward the center of interest or they may act as their own focal point. They may also exist simply to fill space. In this section you'll find a number of ways to paint this versatile element. You'll also find instruction for portraying the lay of the land—mountains, hills, fields and beaches—and gain a few pointers on painting fences and walls.

Textured Rocks

KERRY TROUT & JUDY KREBS

MEDIUM: *Acrylic*

COLORS: **DecoArt Americana:** *Charcoal Grey • Ebony Black • Graphite • Grey Sky • Neutral Grey • Slate Grey*

BRUSHES: *no. 10 flat • no. 2 script liner • ½-inch (13mm) angle shader • scruffy flat*

OTHER SUPPLIES: *chalk pencil • small sea sponge*

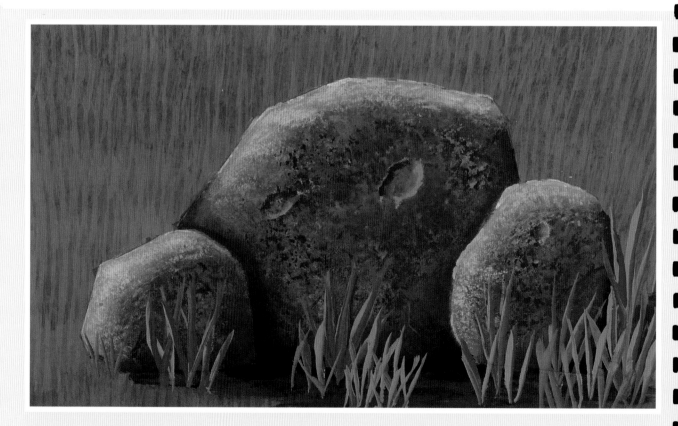

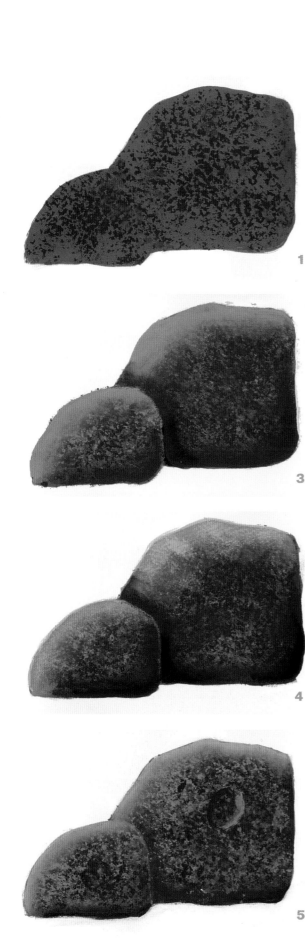

1 Base Paint the Rocks
Use a no. 10 flat to base paint the rocks with Neutral Grey.
Lightly sponge on Graphite with a dampened sea sponge.

2 Sponge On More Grays
Continue to use the sea sponge to lightly sponge on Slate
Grey and Charcoal Grey.

3 Create Highlights and Shadows
Float a Slate Grey highlight on the left and top sides of the
rocks, using the angle shader. Float a Graphite shadow along
the bottom and right sides of rocks and where the rocks
meet. Float larger shadows around the corners of the rocks
to give them roundness.

4 Add Texture, More Shading and Detail
To further highlight and make the rocks more textured, use a
scruffy flat with Grey Sky to drybrush random areas over the
previous highlight. Float a smaller shade in the corners with
Ebony Black over the previous shading of Graphite. Add a
couple of Graphite cracks to the rocks using a script liner.
Have the cracks coming from an edge or corner.

5 Make Indentations
Draw indentations, using a chalk pencil. Using the angle
shader and a mix of Slate Grey + Neutral Grey (1:1), float
tiny shadows on the right or bottom of the inside of the
marks. Float Neutral Grey on the left or top of the inside of
the marks. (*Tip:* The shadow will always be on the opposite
side of the highlight source.) Make sure to leave a small
space between the highlight and shadow of the indentations.

Painterly Rocks

TIM DEIBLER

MEDIUM: *Oil*

COLORS: **Utrecht:** *Cadmium Orange • Cadmium Yellow Light • Naphthol Red Light • Phthalo Blue • Titanium White • Ultramarine Blue*

BRUSHES: *no. 6 bristle flat*

OTHER SUPPLIES: *9" x 12" (23cm x 31cm) gesso-primed Masonite panel • no. 2 pencil • paint thinner • paper towels*

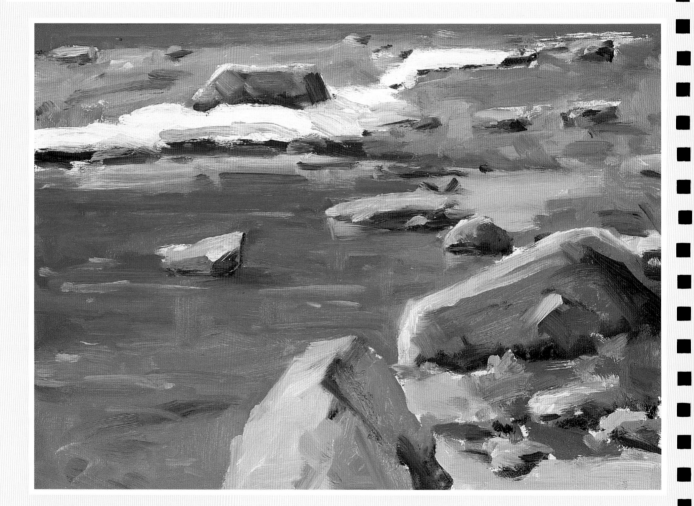

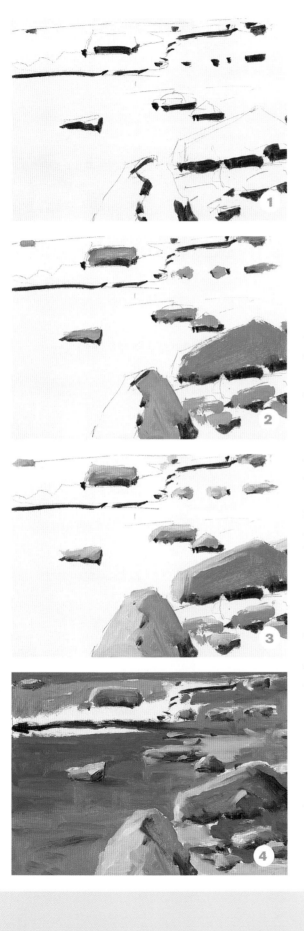

artist's comment

From the tiniest pebbles to the largest boulders, rocks can be used as a supporting element or the main theme in a landscape painting. I find them most useful in leading the viewer through the painting to the point(s) of interest. Varying sizes, shapes and values helps show depth, while the array of colors available can harmonize certain areas or the entire painting. Rocks with sharp angles can have dramatic value changes and crisp edges, while the transitions on rounded river rocks are more subtle.

1 Sketch and Start Thin
Pencil in the basic rock shapes as a guide. Dilute a mix of Ultramarine Blue + Cadmium Orange + Naphthol Red Light with paint thinner and paint all the dark accents.

2 Paint the Shadows
Paint the shadow areas of the rocks with mixtures of Ultramarine Blue + Cadmium Orange + Titanium White. Vary the color slightly from rock to rock by adding touches of Naphthol Red Light and Cadmium Yellow Light. Apply warmer tones in the foreground and cooler tones in the distance.

3 Paint the Light Areas
Add touches of Cadmium Yellow Light and Titanium White to your basic rock mixture and paint the light areas on the left and top sides of all the rocks. Make the tops slightly cooler with a hint of blue, as they are receiving additional light and reflecting the blue sky.

4 Add Surrounding Areas and Refine the Rocks
Paint the surrounding areas of water, grass and bare ground. Then carefully model the shadow shapes of the rocks using warm and cool colors, and re-establish any dark accents that may have been painted out. Place some crisp warm highlights on the sunlit sides of the rocks.

5 Make Final Adjustments
(Refer to the painting on the opposite page.) Put in the small snow bank with Cadmium Yellow Light + Titanium White for the sunny areas and Ultramarine Blue for the shadows. Make sure all the shapes are clear, and add any final highlights and dark accents.

Colorful Rocks

CHUCK LONG

MEDIUM: *Watercolor*

COLORS: **Winsor & Newton:** *Burnt Sienna • French Ultramarine • Raw Sienna • Sap Green • Winsor Violet*

BRUSHES: *1-inch (25mm) flat • no. 12 round • no. 3 hog bristle fan*

OTHER SUPPLIES: *11" x 15" (28cm x 38cm) 300-lb. (640gsm) cold-press watercolor paper • HB pencil • kneaded eraser • a "holey" sponge (with Swiss cheese-like openings)*

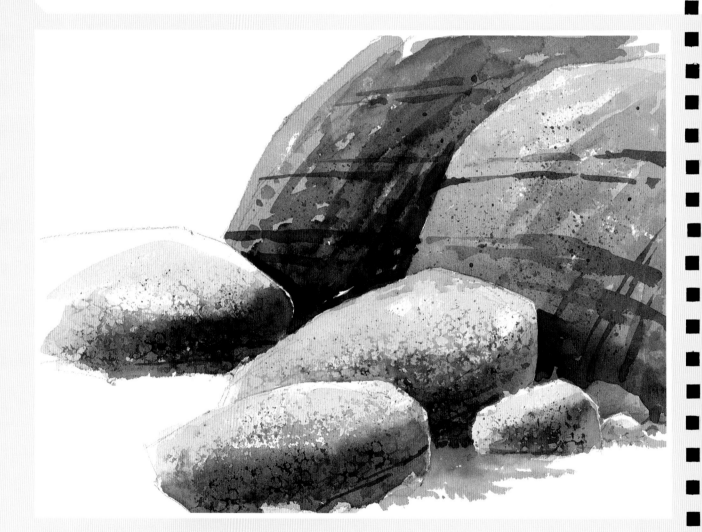

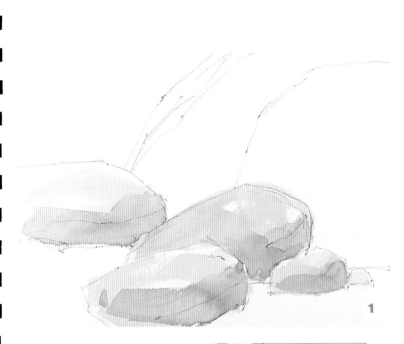

1 Apply First Washes

Make a rough drawing first. Then, with the flat and mixtures of Burnt Sienna, French Ultramarine and Raw Sienna, lay in the first washes over the smaller rocks in the foreground. Strokes should be made quickly, allowing some drybrush for texture to occur.

2 Develop the Forms

Using the round and a combination of Burnt Sienna + French Ultramarine, develop the rock forms by adding shadows and darker values. Soften shadow edges with clean water. Use pure Burnt Sienna for warm reflected light in the shadows. Add Winsor Violet to the combination and paint the background rocks, indicating some texture.

3 Create Texture

Use a sponge to create form and rough texture with Sap Green, French Ultramarine and Burnt Sienna, allowing the colors to run together. Paint and deepen the background rocks with the round and Winsor Violet, French Ultramarine and Burnt Sienna. Add directional strokes for depth, as well as for design and composition.

4 Paint Shadows and More Texture

(Refer to the painting on the opposite page.) With the round and mixtures of French Ultramarine, Burnt Sienna and Winsor Violet, cast shadows from and onto the rocks. Further darken the background. With the same colors and brush, add texture for cracks and so on. Add spatter with the same colors using the fan brush.

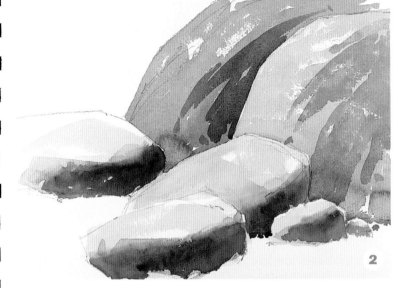

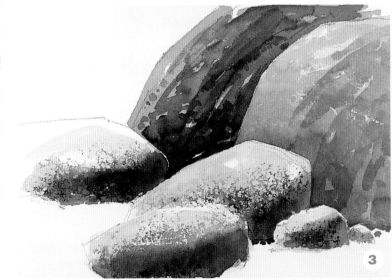

artist's comment

Don't limit yourself to painting rocks in straightforward browns and grays. Colorful rocks make for a more interesting scene and are oftentimes closer to what we actually see in nature than the dull hues generally associated with rocks.

Lakeside Mountains & Hills

SHARON BUONONATO

MEDIUM: *Acrylic*

COLORS: **DecoArt Americana:** *Blue Mist • Burnt Umber • Buttermilk • Hauser Dark Green • Hauser Light Green • Hi-Lite Flesh • Midnite Blue • Plum • Yellow Ochre •* **pale yellow mix:** *Buttermilk + Yellow Ochre (2:1) •* **gray lavender mix:** *Blue Mist + Plum (1:1)*

BRUSHES: **Sharon B's Originals:** *• Crown • Blade •* **Generic:** *1-inch (25mm) flat • no. 3 round • no. 1 liner*

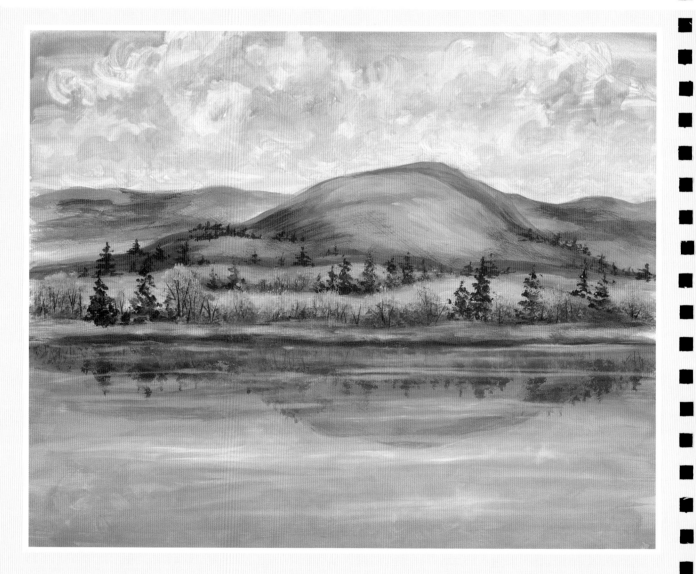

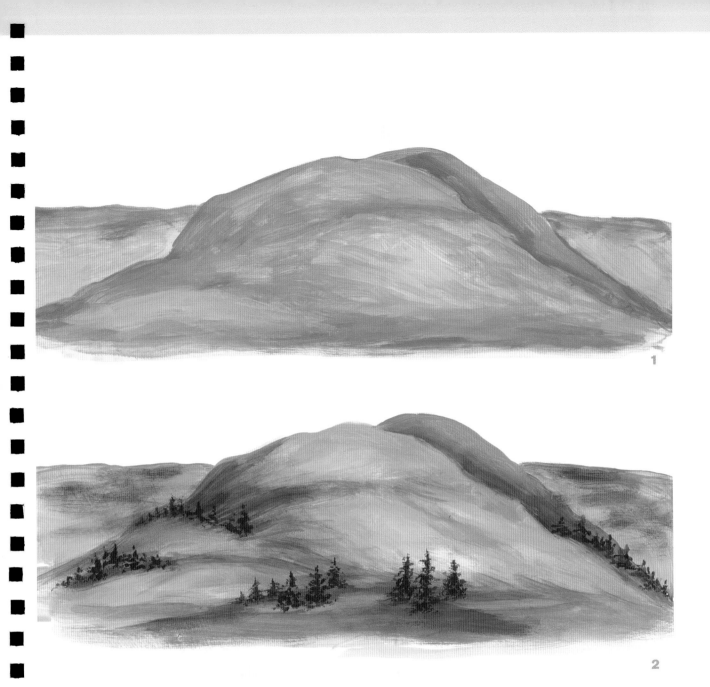

1 Paint the Mountains

Paint the sky and clouds. Then light sketch in the mountains, hills, shoreline and lake reflections. Using a flat, paint the distant mountains with a wash of pale yellow mix. While still wet, streak on overstrokes of gray lavender mix using a Crown brush. Paint the large mountain the same way, adding streaks of Blue Mist, maintaining yellow highlights and lavender shadows.

2 Add Shadows and Trees

With drybrush strokes of a Crown brush, add Plum shadows to the distant mountains. Mix Plum + Burnt Umber for a dark lavender and shade the darkest shadows the same way. Use a round to form lacy pine trees in the shadowed areas.

Lakeside Mountains & Hills

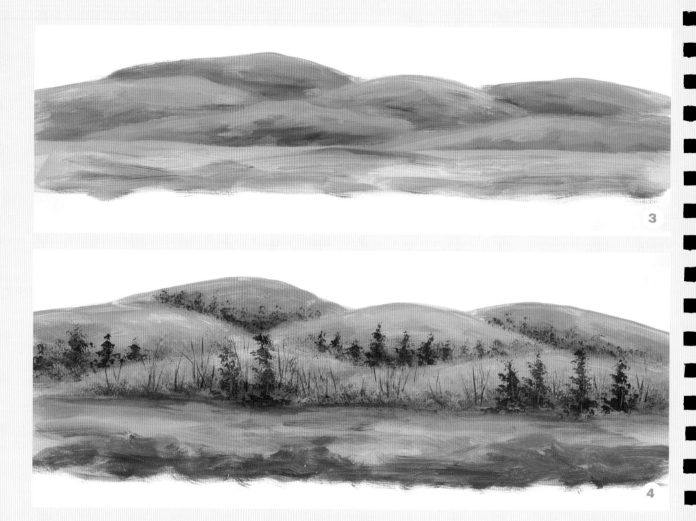

3 Paint the Hills and Shoreline

Using the Crown brush, paint each hill with the pale yellow mix. While still wet, streak Hauser Light Green on top and Hauser Dark Green at the base. Add the pale yellow mix to the top for highlights. Paint the shoreline using the pale yellow mix and the Crown brush streaked with Burnt Umber.

4 Add the Trees and Develop the Shoreline

Add Hauser Dark Green pine trees, using the high tip of the Blade brush in the shadow areas. Tap in small trees between the pines using Hauser Light Green and the chisel edge of the Blade brush. Sprinkle on highlights the same way, using the pale yellow mix. Detail these trees with Burnt Umber trunks and branches using the liner. Drybrush Hauser Dark Green to the previous umber along the base of the shoreline, using a Crown brush.

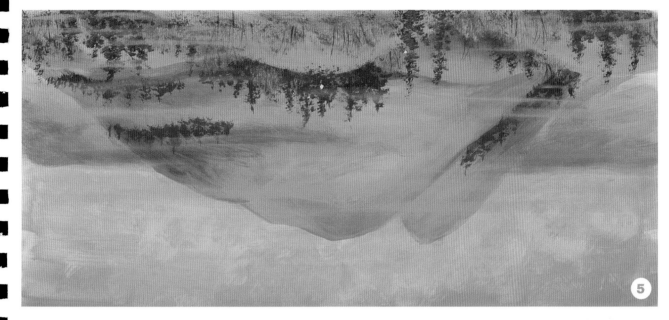

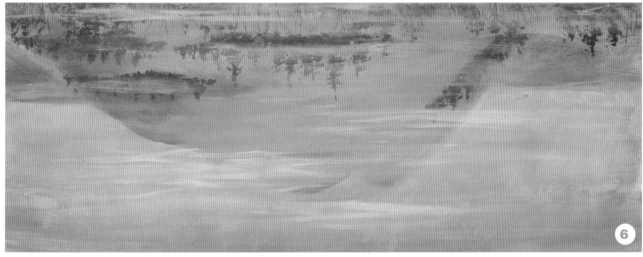

5 Paint the Reflection

Paint the reflective sky, mountains, hills and trees as previously instructed in steps 1 through 4. Then wash over the entire lake with very thin Midnite Blue, using the flat. Wipe the brush and pull light horizontal strokes across the lake to remove excess color wash. Let dry and then redampen with clean water and paint long, horizontal squiggle strokes, forming ripples, using a liner and Blue Mist. Use the flat again to lightly blend the ripples.

6 Add More Ripples and Blend

Let dry and then apply clean water to the surface, using the flat. Then paint ripples as previously instructed, using the pale yellow mix. Add Hi-Lite Flesh ripples the same way. Lightly blend the surface by pulling horizontal strokes across the lake, using the flat.

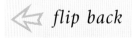

flip back

Turn to page 85 for more tips on painting accurate reflections.

Snow-Capped Mountains

CHUCK LONG

MEDIUM: *Watercolor*

COLORS: ***Winsor & Newton:*** *Alizarin Crimson • Burnt Sienna • Cadmium Yellow • Cerulean Blue • French Ultramarine • Permanent Sap Green • Winsor Blue (Red Shade) • Winsor Violet*

BRUSHES: *nos. 8, 12 & 26 round*

OTHER SUPPLIES: *11" x 15" (28cm x 38cm) 300-lb. (640gsm) cold-press watercolor paper • HB pencil • kneaded eraser*

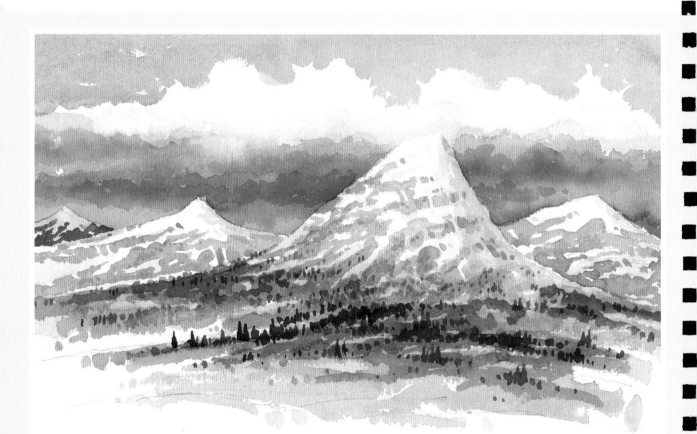

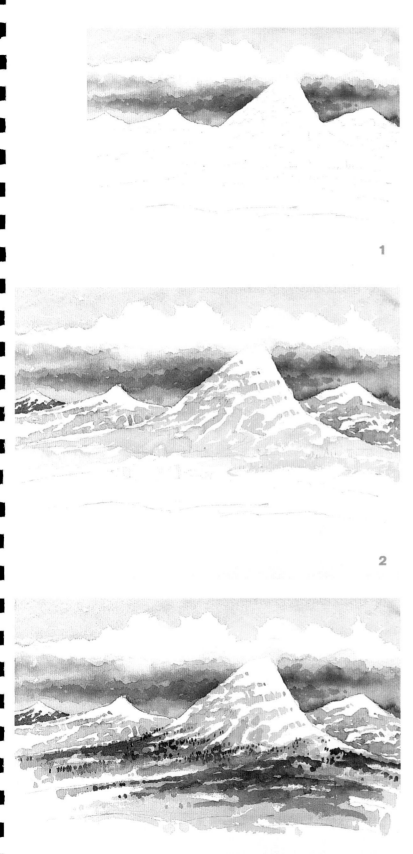

1 Paint the Sky

First make a rough drawing of the scene. Then with a no. 26 round and mixtures of French Ultramarine and Winsor Blue, paint the sky, wet on dry, around the clouds. Below the clouds, add Alizarin Crimson and Cadmium Yellow to the blue to darken the areas around the mountains. Model the lower parts of the clouds to create form.

2 Begin the Mountains

Make a gray using French Ultramarine + Burnt Sienna + Winsor Violet. With a no. 8 round, apply the first washes on the mountains, painting around the snow patches.

3 Develop the Foreground

Paint the hills in the foreground using mixtures of Burnt Sienna, French Ultramarine and Winsor Violet and a no. 12 round. With a no. 8 round and mixes of Permanent Sap Green and French Ultramarine, indicate trees. Let the trees fade as they go up the mountain.

4 Add Shadows and Texture

(Refer to the painting on the opposite page.) Add texture to the large mountain with a no. 8 round and combinations of Burnt Sienna, French Ultramarine and Winsor Violet. Paint shadows on the shaded side of the mountains using the no. 8 round and Cerulean Blue, French Ultramarine, Winsor Violet and Burnt Sienna. Use the same brush to add darker trees with Sap Green and French Ultramarine.

Oceanside Cliffs

MARY DEUTSCHMAN

MEDIUM: *Water-soluble oil*

COLORS: **Holbein Duo:** *Burnt Sienna • Green Gray • Leaf Green • Sap Green • Titanium White • Ultramarine Blue • Vermilion • Viridian • Yellow Ochre*

BRUSHES: **Winsor & Newton:** *a variety flats and filberts nos. 2-8*

OTHER SUPPLIES: *Paper towels*

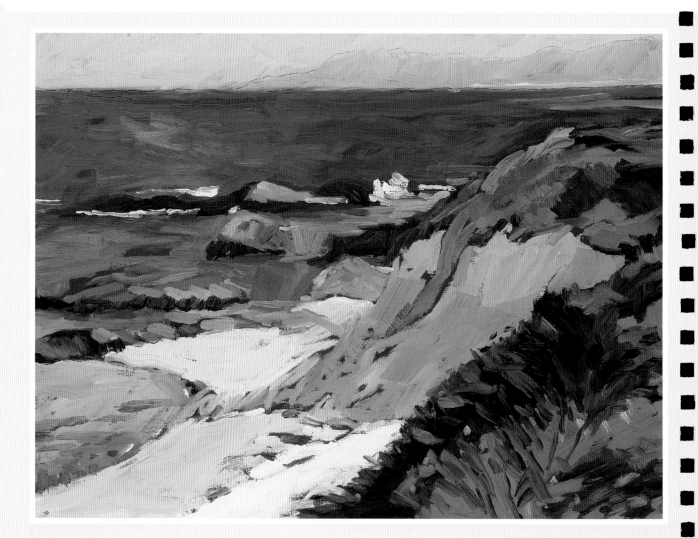

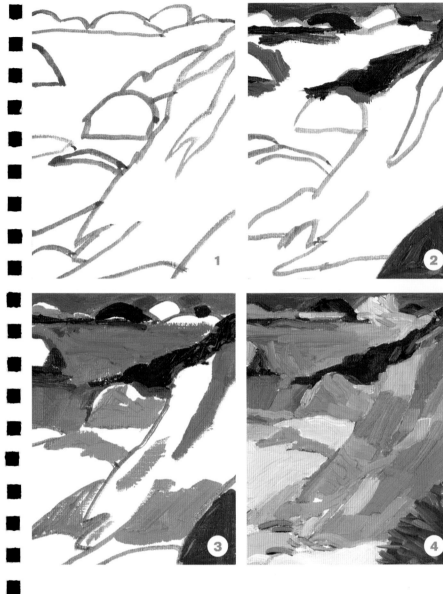

1 Outline Your Plan

With a no. 4 filbert and Ultramarine Blue diluted to a medium value, sketch your design. To make changes, simply wipe off areas using a paper towel dipped in clean water.

2 Paint the Darks

With a no. 4 filbert, add the darkest areas. To the colors for all three main areas, add a little Titanium White just until you can distinguish the color; otherwise all will look black. The ocean is Ultramarine Blue + Viridian + white; the rocks are Burnt Sienna + white; and the vegetation is Viridian + white (or Yellow Ochre).

3 Add the Medium Values

Use a no. 8 flat for the larger areas and a no. 4 filbert for the smaller areas. Add medium values to the water with Ultramarine Blue + Titanium White, sometimes mixed with Viridian. Yellow Ochre + Titanium White + a slight amount of Ultramarine Blue will look like beige in shadow. Resist the temptation to paint the lights or detail before the darks and mediums are painted.

4 Paint the Lights and Detail

Add more Titanium White to the water blue to form a wave. When finishing the cliffs, remember that they have many different planes. Although the cliffs may exist as one color, their planes look different, depending on how they lie in relation to the sun. Vary your strokes with a no. 6 flat to express their direction. Think of painting a cube with one light source.

Use a no. 2 filbert to suggest short, succulent ice plants near the shore. Paint the sand a combination of Yellow Ochre + Titanium White with added Ultramarine Blue in the shadows.

artist's comment

Don't paint just individual landscape elements; paint the elements as they interact with and relate to each other. Make note of where and how they connect. Notice how the jagged cliffs seem to influence the shape of the beach. The water connects the rocks and the sand. The plants on top of the cliffs ooze over the top and trickle down the side. Recognizing these relationships will help make your painted landscapes look natural, not forced.

Rocky Landscape

SANDY KINNAMON

MEDIUM: *Watercolor*

COLORS: ***Winsor & Newton:*** *Burnt Sienna • Cobalt Blue*

BRUSHES: ***Loew-Cornell:*** *Series 7150 ½-inch (13mm) wash/glaze • Series 8000 no. 8 round*

OTHER SUPPLIES: *140-lb. (300 gsm) cold-press watercolor paper • pencil • facial tissues • old, firm toothbrush*

1 First Washes of Color

Pencil in the rocks. Then mix a large puddle of very light Cobalt Blue. With the wash/glaze brush, paint a thin layer of Cobalt Blue on a rock and, while it's still wet, use a tissue to blot off some of the color on the right and top sides of the rock. The color can be irregular, and you should leave some small spots of dry paper here and there. Skip a rock and paint the next rock in the same way. Paint the entire bottom row of rocks in this manner.

Paint the next row of rocks in the same way, but this time make the left and bottom sides of each rock darker. Be sure to wipe the paint off the right and top sides of each rock. Paint any skipped rocks.

2 Add Color to Give Form

Mix a puddle of light brownish gray (Burnt Sienna + Cobalt Blue) and another puddle of light Burnt Sienna. Starting again with the bottom row of rocks, repaint each rock individually, working on dry paper. Paint some Burnt Sienna and others brownish gray. Again, blot the right side and the top edge of each rock.

3 Add Separation and Surface Texture

Make a dark mixture of Burnt Sienna + Cobalt Blue. With the round, create some separation between the rocks and add some small dark areas. Do not outline the rocks. Add lines for cracks if desired.

Cover any areas that you don't want to be spattered with paint. Then take a toothbrush, pick up the same dark mixture and spatter the rocks for texture. If the spatters are too dark, blot slightly with a tissue.

artist's comment

When painting rocks of this kind, start with the lower rocks first and work your way up, as if you were piling rocks on top of each other. Alternate the rocks as you paint, since adjacent wet areas will bleed (run) together. Work your way back to the unpainted rocks after the first rocks have dried some. Try to leave a few specks of white (the paper) showing. All the rocks are painted with the same techniques on dry paper.

Waterside Rock Formations

SHARON BUONONATO

MEDIUM: *Acrylic*

COLORS: **DecoArt Americana:** *Black Plum • Blue Mist • Burnt Sienna • Burnt Umber • Buttermilk • Hi-Lite Flesh • Moon Yellow • Olive Green • Plum • Pumpkin • Sable Brown • Yellow Ochre •* **pale yellow mix:** *Buttermilk + Yellow Ochre (2:1)* • **gray lavender mix:** *Blue Mist + Plum (1:1)*

BRUSHES: **Sharon B's Originals:** *Crown • Blade •* **Generic:** *1-inch (25mm) flat • no. 3 round • no. 1 liner*

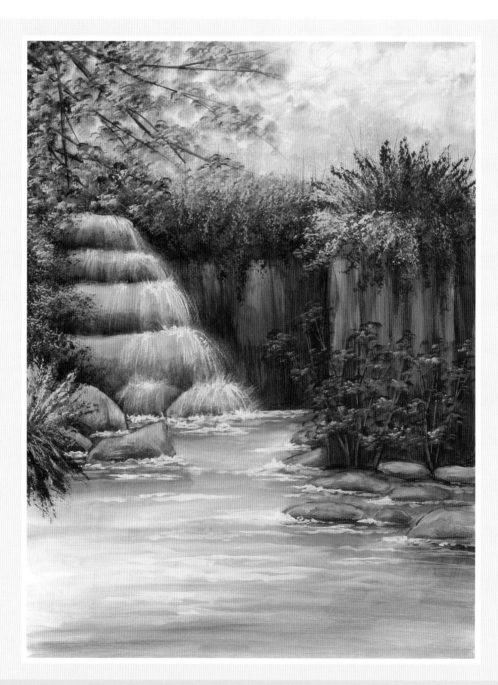

1

2

1 Paint the Cliffs

Brush a wash of thin Buttermilk over the cliffs, using a flat. Pull vertical strokes of Sable Brown, starting at the bottom and using a Blade brush. Pull horizontal strokes on the tops of the cliffs, using the chisel edge of the Blade brush. Add Burnt Sienna shadows at the base and under the top of the cliffs the same way.

2 Add Shading and Define Form

Dampen the cliffs and tint Pumpkin, using the Blade brush in the previous Burnt Sienna areas. Drag on Burnt Umber crevices and vertical shadows, using the chisel edge of the Blade brush. Paint choppy horizontal strokes under the tops of the cliffs in the same manner. Reshade the darkest shadows with Black Plum. Detail using Black Plum and the liner to define each form.

Waterside Rock Formations

3

4

3 Start the Waterfall Rocks

Brush on a wash of thin Buttermilk over the boulders, using the flat. Use Sable Brown and the Blade brush to pull horizontal strokes across each boulder. Shade the base with vertical strokes of Burnt Sienna in the same manner. Also drag a line at the base of each boulder, using the high corner of the Blade brush. Highlight the tops using Moon Yellow and the tip of the Crown brush. *Note:* The rocks are painted the same way, only using the high corner of the Blade brush.

4 Add Shading and Define Form

Using the Blade brush, dampen the boulders and tint Pumpkin in the previous Burnt Sienna areas. Use the high corner of the Blade brush to tint the tops of the boulders and smaller rocks the same way. Using the chisel edge of the Blade brush and Burnt Umber, create crevices and shadows between the boulders and rocks. Then reshade the darkest shadows with Black Plum in the same manner. Detail using Black Plum and the liner to separate each form.

5 Paint the Falling Water

Drybrush the moss on the rocks and boulders, using the tip of the Crown brush and Olive Green. Drybrush the waterfall over the boulders, using the chisel edge of the Blade brush and Blue Mist. Splashes are pulled up and out from the rocks in the same way. Drybrush Hi-Lite Flesh to the top of each waterfall section and rocks, using the high corner of the Blade brush. Finish with highlights for sparkle, using Buttermilk and the liner. Shade the base of each waterfall section and rocks with a float of Black Plum, using the flat on a predampened surface.

6 Paint the Rocks in Water

Paint the stream with a thin wash of pale yellow mix, using the flat. While wet, pull Blue Mist horizontally, using the tip of the Crown brush. Add Buttermilk highlights in the same way. Pull shadows of Sable Brown and gray lavender mix around each rock, using the chisel edge of the Blade brush.

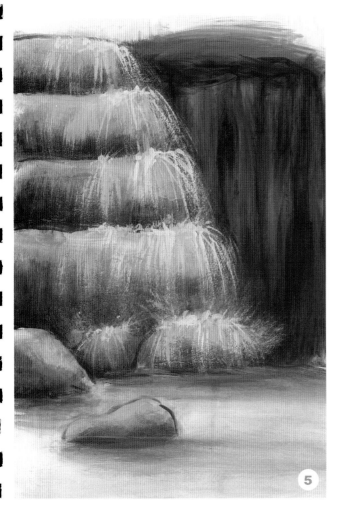

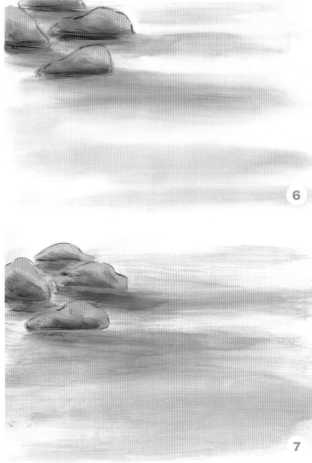

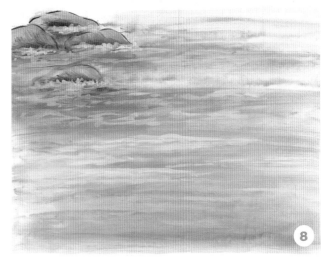

7 Add Reflections and Color

Dampen the stream with water and a flat. Pull horizontal reflections of Burnt Umber in the previous gray lavender area, using the chisel edge of the Blade brush. Add Black Plum reflections with the high corner of the Blade brush, maintaining the previous colors. Add tints of Pumpkin to the stream with the Crown brush.

8 Create Ripples

To form ripples, first dampen with water, using the flat. Then paint horizontal squiggle strokes using the round and Blue Mist. Add Buttermilk ripples in the same way. Darken the shadows in the stream with a float of Black Plum, using the flat. Repaint the ripples under the rocks for sparkle using the liner and Buttermilk.

Moonlit Snow

HUGH GREER

MEDIUM: *Acrylic*

COLORS: ***Golden Fluid Acrylics:*** *Anthraquinone Blue • Diarylide Yellow • Quinacridone Magenta • Titanium White*

BRUSHES: ***Winsor & Newton:*** *Series 580 One Stroke ⅛-inch (3mm), ¼-inch (6mm), ½-inch 13mm), ¾-inch (19mm) & 1-inch (25mm) • no. 0 script (Note: Unless otherwise specified, use large brushes to paint large areas and smaller ones for small areas.)*

OTHER SUPPLIES: *hot-press board • palette knife or rubber-tipped tool • white Saral transfer paper • craft knife • Golden Soft Gel Gloss (clear)*

1 Apply Underpainting and Transfer Drawing
Wash the board with a mixture of Anthraquinone Blue + a small amount of Quinacridone Magenta + a small amount of Diarylide Yellow. Create the desired value by adding Titanium White. This scene requires a darker value to indicate nighttime. Let this dry. Then transfer the drawing onto the board using white Saral transfer paper.

2 Paint Elements of the Landscape
Start with the barn and apply several layers of Titanium White thinned with water. This thin mixture takes on the color of the underpainting. The more layers of white, the brighter and lighter the layers become. The barn itself has one layer of white on the siding and three layers on the roof. Note that the right side of the barn is left as the blue-gray of the underpainting (because it is in shade). Scumble in some distant trees to help define the structure. Use the ¼-inch (6mm) brush for the grasses and the stone fence behind them, and use a script brush for individual blades of grass.

3 Work on the Snow
Now it is time to start layering in the ground snow. Brush this in horizontally. While this white is still wet, take a palette knife or a rubber-tipped tool and give the snow some texture.

4 Develop the Snow With Layering
(Refer to the painting on the opposite page.) Wash in more thin layers, allowing the white paint to dry between each coat. Each layer, while wet, will appear very bright. As each layer dries, it will darken and the color of the underpainting will be visible through the white, making the snow appear a blue-gray. This helps make the painting harmonious in color.

Paint the barn windows with a nearly black mixture of mostly Anthraquinone Blue + a little Quinacridone Magenta + a touch of Diarylide Yellow. Add trees, foliage and fence posts with your smallest one-stroke brush, and use a script brush for fine limb detail. With the point of a craft knife, you can pick out some stars in the sky. Or, if you like, add a few dots of yellow-white for stars. Use the Soft Gel Gloss as a final varnish coat for protection.

Summer Fields

CHRISTOPHER LEEPER

MEDIUM: *Watercolor*

COLORS: **Daniel Smith Watercolors:** *Burgundy Yellow Ochre • Cerulean Blue • Green Gold • Hansa Yellow Light • New Gamboge • Perinone Orange • Permanent Brown • Phthalo Blue (GS) • Quinacridone Coral • Quinacridone Gold • Quinacridone Red • Quinacridone Sienna*

BRUSHES: *¾-inch (19mm) oval wash • nos. 4, 6 & 10 round • no. 6 rigger*

OTHER SUPPLIES: *140-lb. (300gsm) cold-press watercolor paper • Titanium White gouache*

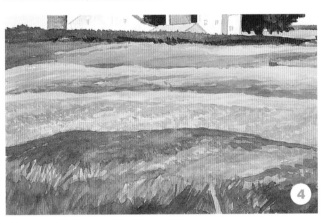

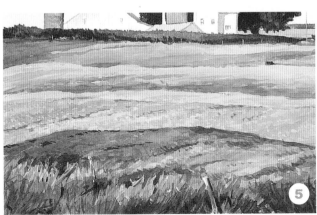

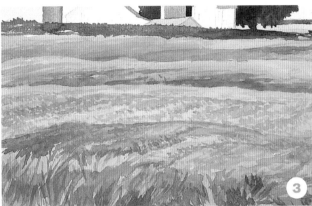

1 Paint First Field Washes

Using the oval wash brush, paint the field with variegated washes of Hansa Yellow Light, Phthalo Blue, New Gamboge, Perinone Orange and Cerulean Blue.

2 Develop Topography and Texture

After the first wash dries completely, develop the field topography and the grass texture. Use a no. 10 round and a diluted mixture of Phthalo Blue + Quinacridone Sienna for the warm-toned washes and New Gamboge + Cerulean Blue for the foreground grasses.

3 Build Texture

Apply several color mixtures, using nos. 4 and 6 rounds, to create textural variety. Mixtures include Green Gold + Cerulean Blue, Green Gold + Burgundy Yellow Ochre, Green Gold + Quinacridone Coral and Quinacridone Gold + Phthalo Blue.

4 Add Shadows

Use nos. 4 and 6 rounds and washes of Phthalo Blue and Cerulean Blue to add the cast shadows. Paint the darkest areas with a mix of Phthalo Blue + Quinacridone Sienna. Add cows in the distant field with a no. 4 round and a mix of Quinacridone Sienna + Permanent Brown.

5 Fine-Tune the Details

Complete final details using a no. 4 round. Paint the darkest values with a Phthalo Blue + Permanent Brown mix. Create more complexity in the foreground grasses with more washes of Phthalo Blue and Cerulean Blue. Use a no. 6 rigger for the finest textures. Add opaque highlights on the fence posts using Titanium White gouache. Add some flowers with small touches of Titanium White and Quinacridone Red.

Beach Sand

TERRENCE L. TSEH

MEDIUM: *Acrylic*

COLORS: *Burnt Umber • Light Cream • Payne's Gray • Raw Sienna • Ultramarine Blue (Note: Color names may vary according to paint brands.)*

BRUSHES: *Small bristle*

OTHER SUPPLIES: *cellular (kitchen) sponge*

1 Apply Base Washes

Apply a wash of Raw Sienna for the sand area and Ultramarine Blue for the water.

2 Add Mottled Color

Mottle Raw Sienna over the sand area, making sure to vary shapes, sizes and values to show the perspective of distance. The spots should appear bigger, darker and rounder in the foreground and gradually become smaller, lighter and flatter as you move toward the background.

3 Spatter Texture

Use a small bristle brush to spatter Burnt Umber, Raw Sienna and Light Cream over the sand area. The dots should be fewer and smaller in the distance.

4 Create Peaks and Dips

Refer to the painting on the opposite page. Dry-sponge Light Cream and mottle for peaks and highlights. Sparingly shade areas of lower dips with Payne's Gray.

artist's comment

Try painting this beach along a wall in your home, perhaps in a child's playroom, for a fun mural effect. Use a cellular sponge for everything except the spattering in step 3.

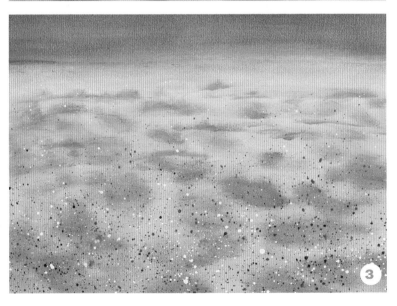

Fences & Walls

KERRY TROUT & JUDY KREBS

Two cross rails behind the pickets support the fence. These should have shadows of the pickets on them.

Shaded sides of fences should be darker than the sides that receive light.

As the picket fence recedes into the background, it gets smaller, and depending on your perspective, the pickets will not have spaces between them.

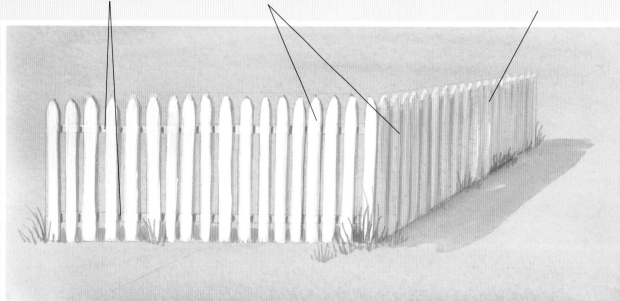

PICKET FENCE

This wall is made of field stones that are basically piled one on top of the other.

Give the nearest rocks the most detail, and lessen the detail as the wall recedes toward the background.

ROCK WALL

Make the posts and rails closer together, lighter in color and less detailed as the fence disappears into the distance.

This fence shouldn't look new, so make some of the posts lean a bit.

Darken the shaded sides and highlight the sunlit edges for lots of contrast.

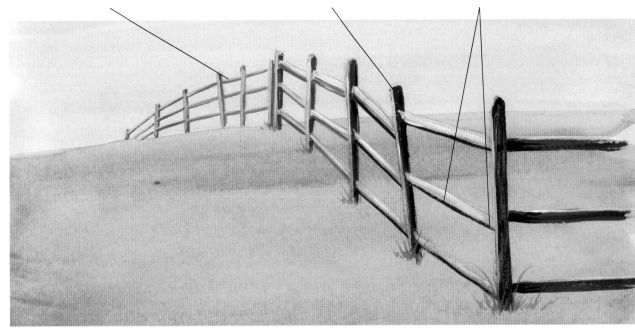

SPLIT RAIL FENCE

Make posts smaller with less detail as they recede into the distance.

Use watery brown on a no. 1 liner to extend the wire along the fence. Always make the wire sag a bit, and paint tiny barbs on the wire only on the wires nearest to the foreground.

Use a scruffy brush to dry-brush highlights onto the posts. This will make the wood look rough.

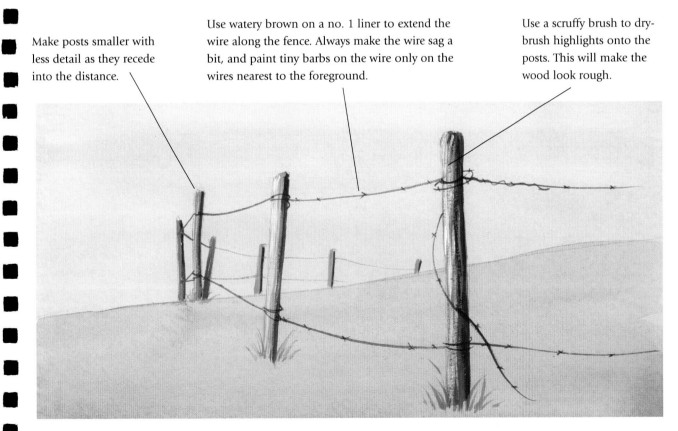

BARBED WIRE FENCE

About the Artists

MARY K. ANDERSON is an accomplished art instructor and lecturer living in Northern California. She teaches art to adults and young people and has conducted painting workshops for more than two decades. Her artwork has appeared in numerous galleries, shows and publications.

SHARON BUONONATO, CDA, was first introduced to decorative painting in 1979 and started teaching in 1980. She became a Certified Decorative Artist in 1987. Sharon is the author of seven books and four videos. She has been featured in numerous painting magazines, and her work also appears in *Painter's Quick Reference: Trees & Foliage*.

BETTY CARR, MFA, teaches painting workshops worldwide. In addition to writing *Seeing the Light: An Artist's Guide* (North Light Books), her work has been featured in *Painter's Quick Reference: Flowers* and in publications such as *The Artist's Magazine* and *International Artist*. She earned a lifetime membership in the exclusive Knickerbocker Artists Society of New York City, and her art appears in numerous galleries in the U.S.

TIM DEIBLER was born and raised in Oklahoma where he studied with many of the area's well-known artists. Among Tim's many honors and awards was a spot in the coveted Top 100 from Arts for the Parks in 1997, and he is the author of *Land & Light Workshop: Capturing the Seasons in Oils* (North Light Books). He teaches painting workshops in his home state of Colorado. His Web site is www.timdeibler.com.

MARY ELIZABETH DEUTSCHMAN worked as a fashion illustrator, designer and art director before a trip to Paris inspired her to study painting. Mary, who works in acrylics, oils, and watercolors, currently teaches painting. She is the author of *No Experience Required! Water-Soluble Oils* (North Light Books). Mary resides in Cleveland, Ohio, and her Web site is www.marydeutschman.com.

KITTY GORRELL is an independent artist, instructor, exhibitor and arts program presenter. She teaches classes and workshops throughout the country. Her preferred medium is oils, but she also paints in watercolors and acrylics. Visit her Web site at www.kittygorrell.com.

HUGH GREER favors traditional realism as a result of working in the architectural field for more than forty years. His artistic achievements include winning the Arts for the Parks grand prize in 2003 and receiving the 2004 Excellence in the Arts "Individual Artist" Award at the 35th Annual Art Awards sponsored by the Arts Council of Wichita, Kansas. Hugh wrote *Acrylic Landscape Painting Techniques* (North Light Books), and he currently has three new teaching videos available. Go to www.hughgreer.com.

KATHI HANSON is an internationally known speaker, demonstrator, instructor and published artist living in Michigamme, Michigan. She has appeared in numerous art magazines including *Tole World*, and she currently has her own brush set and painting kits on the market, distributed by Silver Brush Limited, General Pencil Company and Martin/F. Weber. Her watercolor pencil techniques have been featured on the TV show, *Home Matters*.

TOM JONES, a resident of Central Florida, began painting at an early age and is largely self-taught. His art can be found internationally in many private and corporate collections, including commissioned paintings displayed in the Florida State Capitol Building and Walt Disney World Corporation. Tom teaches students of varying skill levels through nationwide workshops and instructional videos. Visit his Web site at www.tomjonesartist.com.

LINDA KEMP, CSPWC, OSA, SCA, teaches an innovative approach to painting throughout the United States, Canada and the United Kingdom. Her internationally recognized negative-painting concepts are the focus of her book and video, *Watercolor: Painting Outside the Lines* (North Light Books). Her work also appears in North Light's *Watercolor for the Fun of It: Easy Landscapes* by Jack Reid and in *Painter's Quick Reference: Flowers*. Visit www.lindakemp.com.

SANDY KINNAMON, OWS, has been painting watercolors for twenty-five years. She has a B.A. in art and an A.S. in architectural drafting, is the author of two watercolor books, and appears in *Painter's Quick Reference: Flowers*. Sandy has shown her work through the American Watercolor Society and loves teaching. She can be reached at her Web site, www.sandykinnamon.com.

CHRISTOPHER LEEPER graduated from Youngstown State University with a B.F.A. in graphic design. A resident of Canfield, Ohio, he has worked the last 17 years as a fine artist, illustrator and graphic designer. Chris is an adjunct faculty member in YSU's art department, and he is vice-president of the Ohio Watercolor Society. He wrote *Realism in Watermedia* (North Light Books), and he has illustrated four children's books. Visit his Web site at www.christopherleeper.com.

CHUCK LONG, a native of Georgia, attended the Harris School of Art in Nashville, Tennessee. Upon graduation he worked as a freelance artist, designer and illustrator in San Francisco and Los Angeles before settling in Alabama. Chuck currently resides in Huntsville, where he has taught both watercolor and oil painting for over twenty-five years. He is also the author of *Watercolor Success!* (North Light Books).

CLAUDIA NICE, a native of the Pacific Northwest, attended the University of Kansas but gained her realistic pen, ink and watercolor techniques from sketching nature. She spent more than fifteen years travelling across North America as an art consultant, conducting seminars, workshops and demonstrations. Nice is the author of several North Light books, including *Creating Textures in Pen & Ink With Watercolor* and *Watercolor Made Simple With Claudia Nice*.

MARGARET ROSEMAN is the founder, director and a signature member of the Toronto Watercolour Society and has gained signature memberships in the Canadian Society of Painters in Watercolour and the Society of Canadian Artists. Her work has been featured in many art publications, including *Painter's Quick Reference: Flowers*, and may be found in corporate, public and private collections worldwide. She conducts watercolor workshops internationally. Her Web site is www.margaretroseman.com.

RICHARD SCHILLING has worked as a part-time officer on Holland America Cruise Ships, and serves as a short-term volunteer in developing countries. In his book, *Watercolor Journeys* (North Light Books), Richard shares numerous sketchbook paintings derived from his travels. He teaches watercolor technique and "Sketching for the Traveler" in Colorado, and he has written articles on painting for several national magazines. His artwork can be found on www.worldwidewatercolorist.com.

DIANE TRIERWEILER started painting more than twenty-five years ago. She and her husband operate The Tole Bridge, an art shop and teaching facility in Southern California. Diane also teaches all over the United States and Canada. She has published eight books, four videos and one hundred pattern packets, and she has a specialty brush line as well. Her work also appears in *Painter's Quick Reference: Flowers*.

KERRY TROUT and JUDY KREBS own K&J Custom Murals. In addition to being an artist, Judy is a faux and decorative finish expert. Kerry is a self-taught artist who has written four North Light books, including *Handpainted Gifts for All Occasions*. Her work also appears in three other Painter's Quick Reference books: *Santas & Snowmen, Trees & Foliage* and *Flowers*. Her projects are available on CD-ROM.

TERRENCE L. TSEH is currently employed by Deljou Art Group in Atlanta, Georgia, where he designs and produces artwork and posters for galleries and collectors under the aliases of Lun Tse and Onan Balin (see www.deljouartgroup.com). He is the co-author of *Painting Murals Fast & Easy* (North Light Books), and his work also appears in *Painter's Quick Reference: Trees & Foliage*. In his free time, Terrence creates original artwork and murals for private collectors and businesses.

LIAN QUAN ZHEN teaches Chinese and watercolor painting workshops internationally. His paintings appear in numerous institutional and private collections, including the MIT Museum, which has collected fourteen of his works. He has published two titles with North Light Books: *Chinese Painting Techniques for Exquisite Watercolors* and *Chinese Watercolor Techniques: Painting Animals*. His work also appears in *Painter's Quick Reference: Flowers*.

Resources

Cheap Joes Art Stuff
374 Industrial Park Drive
Boone, NC 28607
800.227.2788
www.cheapjoes.com

ColArt Americas Inc.
11 Constitution Avenue
Piscataway, NJ 08854-6145
732.562.0770

Daler-Rowney USA Ltd.
2 Corporate Drive
Cranbury, NJ 08512-9584
609.655.5252
www.daler-rowney.com

Daniel Smith
P.O. Box 84268
Seattle, WA 98124-5568
800.426.7923
www.danielsmith.com

DecoArt, Inc.
P.O. Box 386
Stanford, KY 40484
606.365.3193
www.decoart.com

Golden Artist Colors, Inc.
188 Bell Road
New Berlin, NY 13411-9527
800.959.6543
www.goldenpaints.com

Holbein Artist Materials
HK Holbein
P.O. Box 555
175 Commerce Street
Williston, VT 05495
800.682.6686
www.holbeinhk.com

Jerry Durham
P.O. Box 58638
Raleigh, NC 27658
800.827.8478
www.jerrysartarama.com

Liquitex Acrylics
(See Jerry Durham)

Loew-Cornell
563 Chestnut Avenue
Teaneck, NJ 07666-2424
201.836.7070
www.loew-cornell.com

Masquepen by Cruddas Innovations
www.masquepen.com

Pebeo Drawing Gum
(See Jerry Durham)

Pro Arte Connoisseur Brushes
(See Jerry Durham)

Rembrandt Artist Brand Watercolors
(See Jerry Durham and Cheap Joes Art Stuff)

Robert Simmons Brushes
(See Daler-Rowney USA Ltd.)

Saral Paper Corp.
400 East 55th Street, Suite 14C
New York, NY 10022
212.223.3322
www.saralpaper.com

Sharon B's Originals
759 Slate Quarry Road
Rhinebeck, NY 12572
845.266.5678
www.sharonbsoriginals.com

Silver Brush Limited
P.O. Box 414
Windsor, NJ 08561-0414
609.443.4900
www.silverbrush.com

Utrecht Art Supplies
111 Fourth Avenue
New York, NY 10003
800.223.9132
www.utrechtart.com

Winsor & Newton
(See ColArt Americas)

Index